IMAGES
of America

RICHMOND HILL

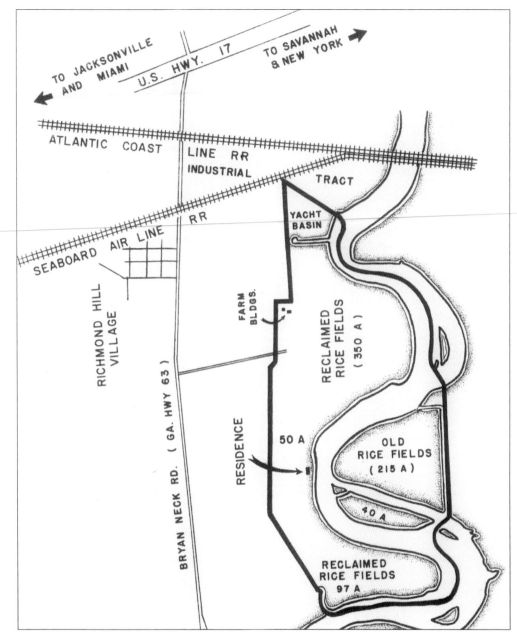

This c. 1952 map delineates the relation of the village of Richmond Hill to the properties of the Henry Ford estate off Bryan Neck Road on the Ogeechee River. The map is from a brochure advertising the sale of the Ford residence and outbuildings for $295,000. (Author's Collection.)

ON THE COVER: Harry G. Ukkelberg studies samples through his microscope at the Richmond Hill Plantation Research Laboratory c. 1938. Ukkelberg was the director of the laboratory for Henry Ford, basing much of his work on the Ford agricultural operations along the nearby Ogeechee River (Courtesy of Richmond Hill Historical Society.)

IMAGES
of America

RICHMOND HILL

Buddy Sullivan
in association with
the Richmond Hill Historical Society

ARCADIA
PUBLISHING

Published by Arcadia Publishing
Charleston, South Carolina

Printed in the United States of America

Library of Congress Catalog Card Number: 2006925652

For all general information contact Arcadia Publishing at:
Telephone 843-853-2070
Fax 843-853-0044
E-mail sales@arcadiapublishing.com
For customer service and orders:
Toll-Free 1-888-313-2665

Visit us on the Internet at www.arcadiapublishing.com

*To the memory of Dr. Franklin Leslie Long and Lucy Bunce Long
in remembrance of their years of unstinting devotion to gathering,
preserving, and recording the history of Richmond Hill; their efforts
in the creation of the Richmond Hill Historical Society; and their
unflagging vision incorporating hope for a purposeful understanding
of the past while reaching toward the future of the community they loved.*

CONTENTS

ACKNOWLEDGMENTS

This project may be said to have had its genesis in the fall of 1991, when I first made the acquaintance of community historians Dr. and Mrs. Leslie Long and my consequent involvement in the Richmond Hill Historical Society, which they helped found. It was Dr. Long who subsequently started me on the path to my own investigations of the history of Richmond Hill and Bryan County. In 2000, this resulted in my writing, through the auspices of the Commissioners of Bryan County, an official county history, *From Beautiful Zion to Red Bird Creek: A History of Bryan County, Georgia*, a documented 450-page compendium based on the rich lode of official records of the county, plantation records, and public and private manuscript collections. Though not intentional, my book on Bryan County followed as a companion volume, both in style and substance, to the Longs' own extensive work, *The Henry Ford Era at Richmond Hill*, their remarkable personal memoir published two years earlier in 1998. Thus, those seeking more comprehensive information on the subject of Richmond Hill and its environs should consult the aforementioned two volumes.

Based on my earlier researches and publications on the subject, it seemed only natural that I embark on a productive collaboration with the Richmond Hill Historical Society (RHHS) to prepare this collection of photographs as part of Arcadia's Images of America series. By way of acknowledgment, I must emphasize that the collective spirit and energy of Lucy and Leslie Long abide and pervade every page of this small volume, which I am honored to dedicate in their memory. For without the generosity of the Longs, who bequeathed their extensive collection of photographs and historical materials to the RHHS as part of their estate, there would have been enormous difficulty in compiling an adequate range of images for this book. Most of the Longs' material now in possession of the RHHS Museum archives relates to the Henry Ford era at Richmond Hill. It should be noted that the Longs' acquisition of their Ford-era collection was made through their purchase of the images from the Henry Ford Museum and Greenfield Village at Dearborn, Michigan. All images, unless otherwise noted, are courtesy of the Richmond Hill Historical Society.

I especially wish to acknowledge Gayle Phillips, manager of the Richmond Hill Museum, who provided invaluable assistance in gathering images; the Richmond Hill Historical Society Board of Directors; Paul Weinberger, who suggested I prepare this book; and Dale and Jackie Mitchum for their support of all my projects—their enthusiasm is exceeded only by their love of Richmond Hill.

INTRODUCTION

The history of Richmond Hill goes back to the earliest days of the Georgia colony when, in 1733, Gen. James Oglethorpe built Fort Argyle near the confluence of the Ogeechee and Canoochee Rivers to protect the western approaches to Savannah. The legalization of slavery in 1750 and the availability of highly cultivable agricultural bottomland along the Ogeechee River led to rapid settlement in lower St. Philip Parish (Bryan Neck) through the issuance of crown land grants prior to the Revolution. Surveyor Henry Yonge laid out the new town of Hardwicke on the Ogeechee, with lots surveyed and granted between 1753 and 1767. Hardwicke was intended by its investors to be the new provincial capital of Colonial Georgia, but the project was unsuccessful because of the increased prominence of the nearby port of Sunbury.

In 1793, Bryan County was created from Chatham and Effingham Counties, being named in honor of Colonial planter and Revolutionary patriot Jonathan Bryan (1708–1788). The earliest meetings of county officials were held at Strathy Hall plantation before the local seat of government was moved to Cross Roads at the intersection of the Darien-Savannah Stage Road and the Bryan Neck Road, later the site of Richmond Hill. As the population of the area expanded into the Bryan County hinterlands north of the Canoochee River, the county seat was moved again in 1815, this time to Eden, which in 1886 was renamed as the unincorporated township of Clyde.

The proximity of the Ogeechee River in the section that later became Richmond Hill was the salient factor in rice evolving as the primary cash crop of the local agricultural economy. The earliest Ogeechee rice plantations in the vicinity (pre-and post-Revolutionary War) were those of Thomas Savage and his heirs at Silk Hope and of the Harns, followed by the Habershams, at Dublin. Lower Bryan County was the locale of some of the most productive rice and Sea Island cotton plantations of tidewater Georgia in the four decades prior to the Civil War.

The larger rice tracts were those managed by the leading slave owners. These included the several plantations of Thomas Savage Clay, the largest being Richmond-on-the-Ogeechee (formerly Dublin), later managed by his sister, Eliza Caroline Clay. The Clays also operated Tranquilla, Tivoli, and Piercefield, the latter three being largely devoted to the cultivation of provision crops and cotton. Richard James Arnold of Providence, Rhode Island, had two large holdings, Cherry Hill (the rice tract adjacent to Richmond), and White Hall farther downriver. Arnold additionally had several smaller rice tracts, including Orange Grove, Mulberry, Sedgefield, and half of Silk Hope, all within the present town limits of Richmond Hill. George Washington McAllister planted rice at Strathy Hall and cotton at Genesis Point; the Maxwell family cultivated various holdings throughout Bryan Neck, chiefly in the vicinity of the Belfast River; and Charles W. Rogers was the section's largest cotton planter at Kilkenny on the lower end of the neck. Of these, R. J. Arnold was the most prominent. According to the U.S. agricultural census of 1860, he owned 11,000 acres in lower Bryan County, with 195 slaves cultivating the lower Ogeechee's largest rice yields supplemented by two other primary staples, sugar cane and Sea Island cotton. Arnold's rice crop in 1859 was listed as 665,000 pounds, by far the largest of the local planters.

The agricultural economy of the section was enhanced by the completion of the Savannah-Ogeechee Canal in 1830 near Kings Ferry. The Savannah, Albany, and Gulf Railroad was built to link Savannah with southwest Georgia. Tracks were laid across the Ogeechee and into Bryan Neck in 1856, traversing the Silk Hope rice fields of Richard Arnold and William J. Way. The station depot was designated Ways No. 1 1/2. A settlement developed there between the tracks and the Cross Roads and came to be known as Ways Station, the forerunner of Richmond Hill.

In 1861, in response to Union naval threats to the southern approaches of Savannah, Fort McAllister was built on the Ogeechee at Genesis Point, several miles southeast of Ways Station. This earthwork fortification repelled seven Union naval attacks in 1862 and 1863, including assaults by heavily armed Monitor class gunboats. The CSS *Rattlesnake* (former CSS *Nashville*), a Confederate blockade-runner, sought refuge in the Ogeechee but was burned and sunk in the river near Fort McAllister by Union gunfire in February 1863. In December 1864, Bryan Neck was invaded by elements of the right wing of Gen. William T. Sherman's forces as they neared Savannah. In a short, intense battle, Fort McAllister was overwhelmed by superior Union forces, which had crossed the river at Kings Ferry then marched down Bryan Neck to assault the fort from its largely unprotected landward side.

After the Civil War, emancipated African Americans on Bryan Neck began to purchase their own land from the heirs of the plantation owners. Amos Morel, the head slave for Richard J. Arnold, became the most prominent freedman of the section as well as the largest landowner. New settlements of the former slaves were established at Brisbon, Rabbit Hill, Port Royal, Oak Level, Fancy Hall, and Daniel Siding. Blacks worked for wages at the revived Ogeechee River plantations, and the section prospered until hurricanes in the 1890s forced the abandonment of the rice industry in tidewater Georgia. Later many blacks found employment in the local lumber industry. In 1901, the Hilton-Dodge Lumber Company of Darien opened a sawmill and timber port on the Belfast River, activity that continued until 1916.

In 1925, Henry Ford of Dearborn, Michigan, began purchasing land on Bryan Neck, eventually owning about 85,000 acres on both sides of the Ogeechee. Ford was interested in the social and agricultural improvement of the area around Ways Station, then one of the most impoverished places in coastal Georgia. Ford began agricultural operations; provided housing and medical facilities; and built churches, a community center, and schools for blacks and whites. He developed a sawmill, vocational trade school, improved roads, and other infrastructure and generally brought Ways Station into the 20th century. In 1941, the town's name was changed to Richmond Hill in honor of Ford, who had built his winter residence, Richmond, on the site of the former Clay plantation.

In early 1941, the federal government condemned 105,000 acres of sparsely settled land in the center of Bryan County for the Camp Stewart U.S. Army training base. The coming of Camp Stewart necessitated the relocation of all civilian residents of the middle section of Bryan, including the small communities of Letford, Roding, and the county seat at Clyde. Many of these displaced residents built new homes in Richmond Hill. Henry Ford died in 1947, followed in 1951 by the sale of his Richmond Hill plantation, in addition to his other holdings on Bryan Neck, to the International Paper Company. The Ford operations at Richmond Hill were officially suspended June 30, 1952.

On March 3, 1962, the township of Richmond Hill was incorporated through an act of the Georgia legislature. The first city elections were held, with the first mayor (L. C. Gill) taking office in March 1963. The population of the town at the time of incorporation was about 500 residents. Richmond Hill remained a quiet, rural community built along both sides of U.S. Highway 17 until rapid suburban growth from nearby Savannah began in the 1980s.

One

THE RICE ARISTOCRACY

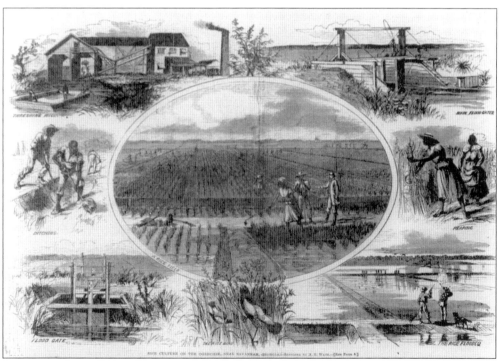

Beginning about 1760 and lasting until shortly after 1900, rice was the chief agricultural staple grown in the section of the Ogeechee River that was later to become the town of Richmond Hill. This composite sketch depicting the various aspects of the tidewater rice industry from planting to processing was rendered by A. R. Waud in 1866 during a visit to the Ogeechee and was published soon after in *Harper's Weekly*. The peak of rice cultivation occurred in the years immediately before the Civil War.

The Ogeechee is one of five major freshwater rivers that flow from the uplands of Georgia into the Atlantic Ocean. Richmond Hill is on the Ogeechee only a few miles from the sea. Like similar streams along the South Carolina and Georgia coasts, the section of river delta where fresh water mixed with saltwater under tidal influences is where rice cultivation prospered. Tidewater planters grew rice on both sides of the Ogeechee near present-day Richmond Hill in irrigated fields on the Bryan and Chatham County sides of the river.

HARDWICKE

This site on the Great Ogeechee, 14 miles from the Atlantic, was selected in 1755 by Governor John Reynolds for the capital of Georgia. He named it for his kinsman, Lord High Chancellor of England, Philip Yorke Hardwicke. Reynolds said: "Hardwicke has a charming situation, the winding of the river making it a peninsula and it is the only fit place for the capital." In 1761, Sir James Wright, the Province Governor, determined against the removal of the capital from Savannah. Hardwicke then became little more than a trading village and it is now noted among "the dead towns of Georgia."

Hardwicke was the first "planned" town of what later became Bryan County. Two decades before the American Revolution, it began to be surveyed and laid out on the Ogeechee at the lower end of the Seven Mile Bend, not far from the later site of Fort McAllister. Hardwicke never attained the promise held for it, as its location between the already thriving ports of Savannah (to the north) and Sunbury (southward) precluded any possibility of it becoming a commercial center. Nothing remains of the dead town of Hardwicke.

Thomas Savage Clay (1801–1849) was one of the most prominent of the Bryan Neck rice planters. Descended from two of the most influential early families of Colonial Georgia, the Savages and the Clays, Thomas Clay and his mother, Mary Savage Clay, purchased Dublin, a rice plantation on the Ogeechee, and renamed it Richmond in 1821. It was located on the site that became the winter home of Henry and Clara Ford over a century later. Here Clay produced rice in large quantities and was regarded as a humane and benevolent slave owner.

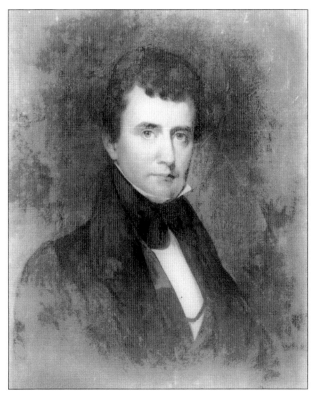

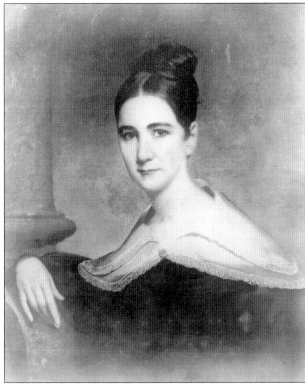

Matilda Willis McAllister Clay (1818–1869) was the wife of Thomas Savage Clay. The daughter of a neighboring planter, George W. McAllister of Strathy Hall plantation, she married Clay in 1836. Thomas Clay died unexpectedly at the age of 48 in October 1849. His sister, Eliza Caroline Clay, capably managed the various Clay plantations on Bryan Neck after her brother's death.

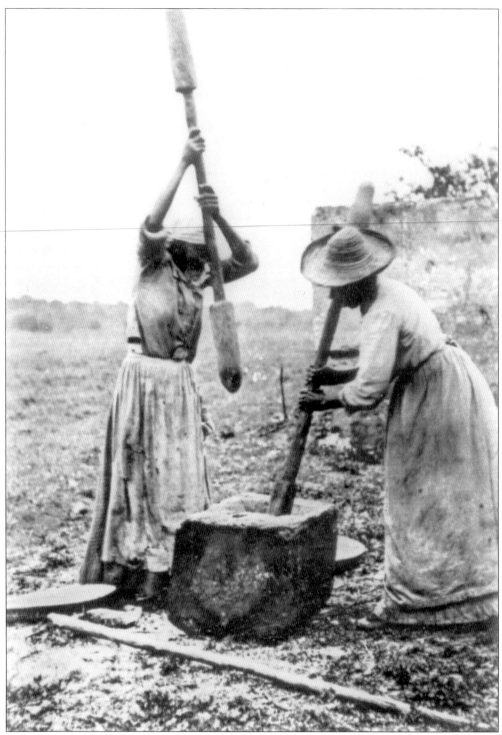

Plantation workers are shown pounding rice utilizing wooden pestles. The rice hulls are removed from the grain in this process.

Richard James Arnold (1796–1873) was Bryan County's most prominent planter. On the eve of the Civil War, Arnold owned 195 slaves and 11,000 acres. His plantations on the Ogeechee River included his White Hall residence and his rice tracts of Cherry Hill (the largest), Silk Hope, Sedgefield, Mulberry, and Orange Grove. Like his neighbor, Thomas S. Clay, Arnold was a liberal and humane slave owner. Arnold, a native of Rhode Island, and his family divided their year between North and South, spending their winters at their Georgia plantations. (Courtesy of Arthur Arnold Rogers.)

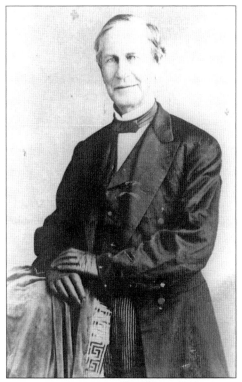

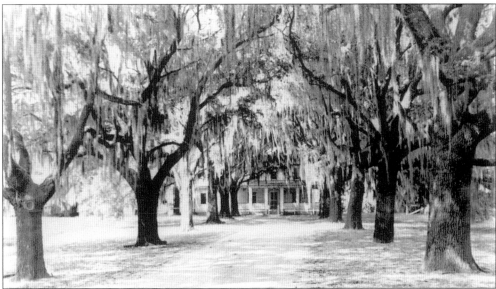

The avenue of moss-draped live oaks leading to the overseer's house at Cherry Hill plantation provides an evocative image of Bryan Neck in the years just before, during, and after the Civil War. Cherry Hill was R. J. Arnold's most active agricultural operation. The preponderance of Arnold's rice was produced at Cherry Hill, and the majority of his slave force lived there. He also produced sugar and molasses in his sugar mill at Cherry Hill. The original house was burned during the Civil War . The house shown was built in 1874 by one of Arnold's sons, William Eliot Arnold. (Author's Collection.)

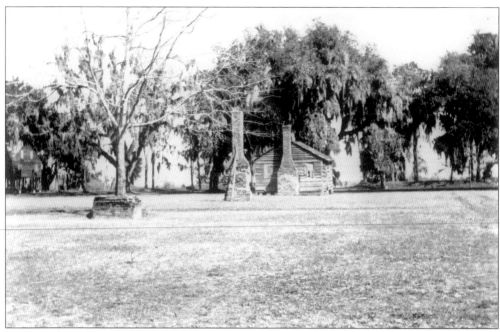

In 1925, when Henry Ford acquired the property on the Ogeechee River on the site of the former Richmond rice plantation, there were scattered buildings, such as the cabin shown above, as well as the brick ruins of the chimneys of former slave dwellings. Many of the slaves of Thomas S. Clay's plantations lived near the main house at Richmond, in close proximity to the rice fields where they toiled six days a week under the task system labor.

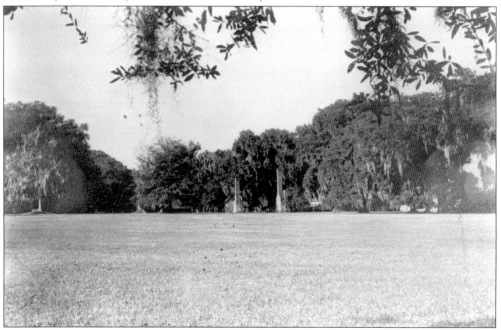

A number of the slave cabin remains, particularly those such as the brick chimneys shown above, were restored and left standing during the improvements made on the Richmond tract by Henry and Clara Ford in the early 1930s. This picture was taken c. 1935.

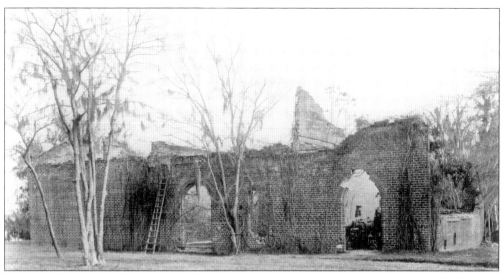

The brick remains of the steam-powered rice mill at Richmond plantation are testimony to the golden era of rice cultivation on the Ogeechee River, the peak years of which were the 1840s through the 1870s. The larger, wealthier rice planters typically had their own mill complexes for threshing and pounding (polishing) their rice crops, thus eliminating the additional cost of having the Savannah mills process their crop. Smaller tidewater planters contracted with the Clays, Arnolds, and others to prepare their rice for market. The largest rice mill in the Ogeechee district was across the river on the Chatham County side at the Grove Point plantation of John Cheves.

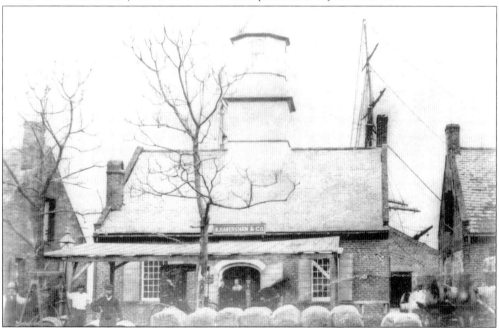

Most local planters marketed their staple (cash) crops at the nearby port of Savannah, where the cotton and rice agents (factors) were paid a commission for selling the crops of their clients. Many of the Ogeechee planters used the factorage of Robert Habersham and Sons, pictured above c. 1860, located on Bay Street in Savannah. Bryan County's rice and cotton were shipped to markets in the northeastern United States and overseas to Great Britain and the Mediterranean area.

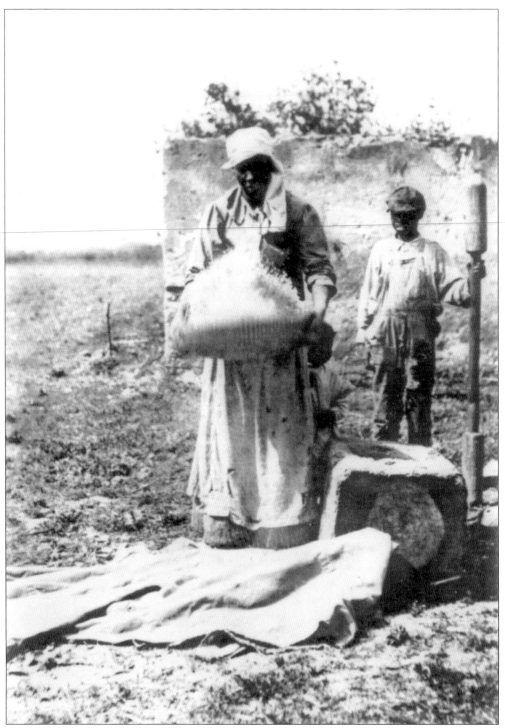

Fanning the rice entailed separating the grain from the chaff, or residue of the rice hulls, using fanner baskets made from sweetgrass, as shown above.

With the coming of the Civil War in 1861, Georgia military officials began preparations to fortify the state's coastline against the Union blockade. That year, earthen gun emplacements were constructed by Confederate engineers and slaves at Genesis Point on the Ogeechee River on land provided by local planter Joseph L. McAllister, whose name was given the fort. Fort McAllister, pictured at right, was heavily armed and successfully repelled seven Union naval assaults in the 1862 and 1863, forcing heavily armed Passaic class monitors to retreat to the deeper waters of nearby Ossabaw Sound.

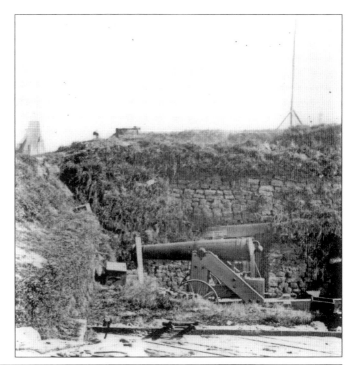

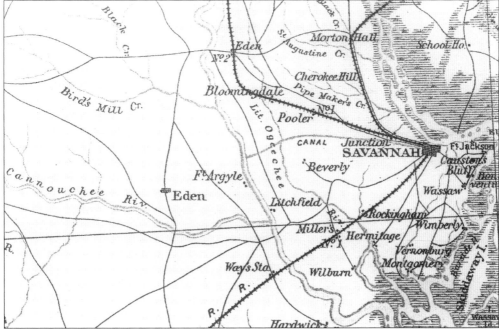

Gen. William T. Sherman's march through east Georgia following the capture of Atlanta reached the coast in December 1864. The map above delineates the sphere of operations for Sherman's forces in the environs of Fort McAllister. The Bryan County seat of Eden (later Clyde) was taken by one federal unit, while cavalry forces led by Gen. Judson Kilpatrick carried out raids on the Bryan Neck between Ways Station and Fort McAllister, thus securing the Savannah, Albany, and Gulf Railroad on both sides of the Ogeechee River.

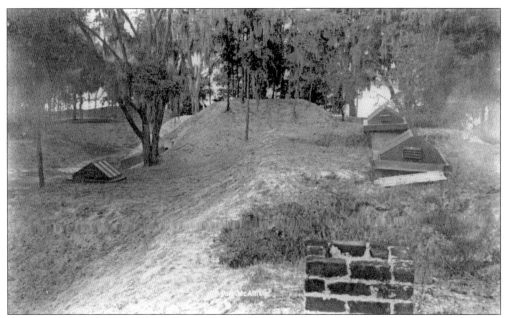

At Fort McAllister, above, Maj. George W. Anderson and his outnumbered force of Confederate defenders (only 200 men) dug in expecting a landward assault from their rear. Sherman had to neutralize Fort McAllister to secure his rear before attacking Savannah in addition to clearing the way to Ossabaw Sound where Union naval vessels would be able to supply his army. The Union attack on the fort was set for December 13, 1864.

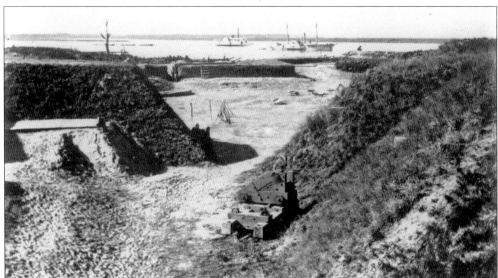

Gen. William Hazen's 2nd Division (primarily Ohio and Illinois regiments) of Gen. Oliver O. Howard's 15th Army Corps was selected to make the attack on Fort McAllister. They crossed the Ogeechee upriver from the fort on pontoon bridges at King's Ferry then marched down Bryan Neck seven miles to make a late-afternoon attack. This followed a bombardment of the fort by Sherman's artillery emplaced at Cheves' mill two and a half miles upriver. The Union force overwhelmed McAllister after short but very bloody action. The next day, as shown above, Union naval vessels anchored off the occupied fort.

Two

ENTER MR. FORD

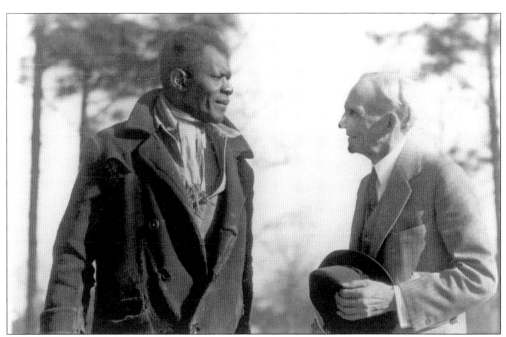

After the Civil War, many local residents turned their livelihood to the pine forests that abounded the area. The pines were tapped for gum rosin, by which turpentine was distilled. The Hilton-Dodge Lumber Company began extensive sawmill operations at Belfast on the other side of Bryan Neck, activity that reached a peak in 1910. Lean years followed until the arrival in 1925 of automotive pioneer Henry Ford (1863–1947), shown above at right with Will Showard. Ford began purchasing what eventually amounted to 85,000 acres of land on both sides of the Ogeechee River.

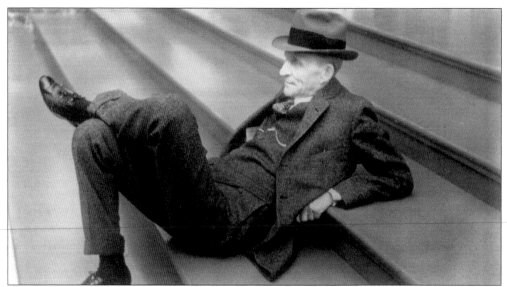

By the late 1930s, Henry Ford, shown relaxing on the steps of his winter home on the Ogeechee River, eventually owned most of the land in lower Bryan County, including the old rice plantations Cherry Hill, Richmond, Strathy Hall, and White Hall, along with other large tracts such as Belfast, Cottenham, and Kilkenny. Some properties Ford did not acquire, including lands at the Cross Roads (Highway 17 and Bryan Neck Road) owned by the two Miner brothers, who operated a gas station and a grocery store. Another tract that Ford did not obtain was that of Gordon Carpenter (died 1957), who owned a store at Keller, about 10 miles down Bryan Neck Road from Ways Station. One of the first things Ford did was drain the malarial bottomlands of his properties along the Ogeechee to reduce mosquito infestation. The drainage project eliminated a serious health problem around Ways Station.

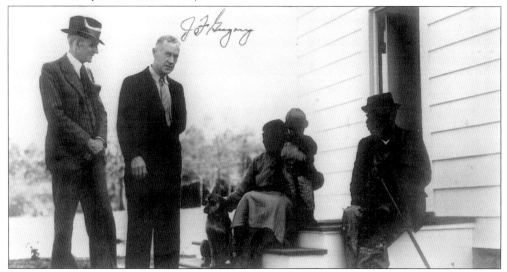

Ford (left) and his superintendent of the Richmond Hill plantation, Jack Gregory, are pictured with several members of the local African American community in this rare photograph. Gregory was the overall supervisor of the large operation at Richmond Hill from the early 1930s until 1946. As seen in this view, Ford often interacted with residents of the local community, black and white, during his visits to Richmond Hill from Dearborn.

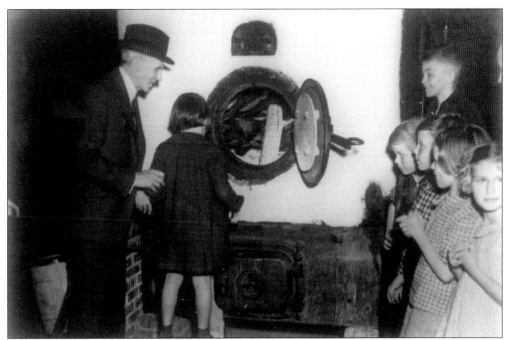

Ford enjoyed spending time with the school children of Richmond Hill. Here he is showing a group of children how a steam boiler produces power for the generator that provides electricity for the main house at Richmond.

Here Ford, right, is discussing the progress of work in the plantation's machine shop with Clarence Smith, principal of Richmond Hill High School in the late 1930s. Ford built an Industrial Arts and Trade School in Richmond Hill where local students, including many young adults, received specialized vocational training in various trades such as welding, machine shop work, carpentry, and other skills. Through the 1930s and 1940s, there were increasingly strong links between local education and the operations of Ford on Bryan Neck.

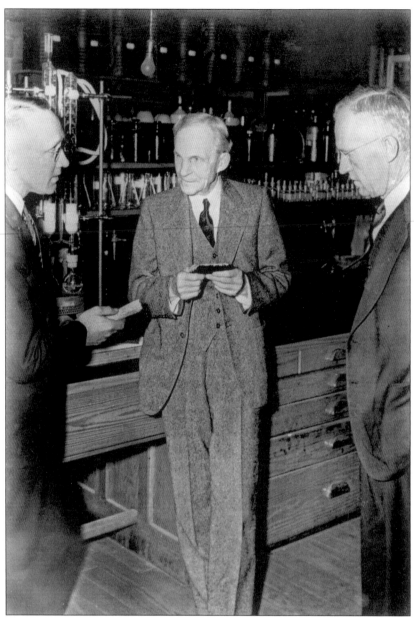

Ford typically took a personal interest in all aspects of his Richmond Hill operation. His initial interest in acquiring his Bryan County lands was fueled by a desire to develop rubber-tree farms in the semi-tropical climate of the Southern coast. In this regard, he engaged in frequent discussions with two close friends, Harvey Firestone, who produced tires for the Ford Motor Company at Dearborn, and Thomas A. Edison of Fort Myers, Florida, who had theories on the United States' domestic production of rubber for the automotive industry. The rubber experiments eventually came to naught at Richmond Hill due to inadequate soil conditions, but agricultural experimentation became an integral part of the Richmond Hill operations. Here Ford (center) is shown holding a piece of plastic made in the Richmond Hill laboratory from corn cobs. With Ford are laboratory director and farming operations supervisor Henry Ukkelberg (left) and plantation superintendent J. F. (Jack) Gregory.

22

Ford made the friendship of George Washington Carver, a well-known educator and botanist at Tuskegee Institute in Alabama. Ford was impressed with Carver's research and contributions to the improvement of agricultural techniques, including his experimental work in peanut and sweet potato cultivation. Ford visited Carver at Tuskegee and later named the African American school which he built in Richmond Hill for Carver. This photograph was taken on the occasion of Carver's attendance of the school's dedication ceremonies in March 1940.

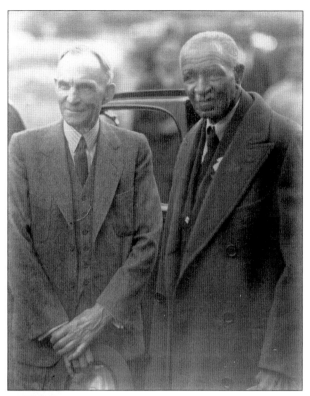

Henry and Clara Ford made annual extended visits to Richmond Hill during the 1920s and 1930s and, in 1936, they built their permanent winter residence, which they named Richmond, on the banks of the Great Ogeechee. Many of the photographs in this section depict Ford in a greatcoat, testimony to the fact that the Fords' visits to Richmond Hill occurred in the winter months.

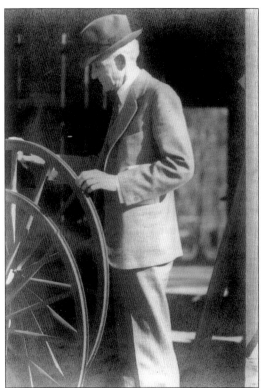

Ford's farming operation on Bryan Neck eventually exceeded 3,000 acres, and extensive crops of vegetables, including a high quality of iceberg lettuce, were cultivated on the reclaimed rice fields along the Ogeechee. At the same time, turpentine distilleries and a sawmill were built to tap the local pine forests. These endeavors provided employment for hundreds of people, thereby transforming what once was one of the more impoverished areas of coastal Georgia into one of the most thriving—and this occurring during the worst years of the Great Depression 1930–1940

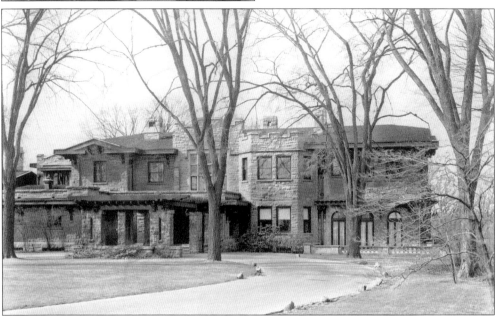

Shown is the front entrance and driveway approach to Fair Lane, Henry and Clara Ford's Dearborn, Michigan, estate. Dearborn was the home of the Ford Motor Company and the headquarters for all the Ford operations around the United States, including those at Richmond Hill. Most of the documents and reports of Ford's activities around Richmond Hill are on deposit at the Ford Archives in Dearborn.

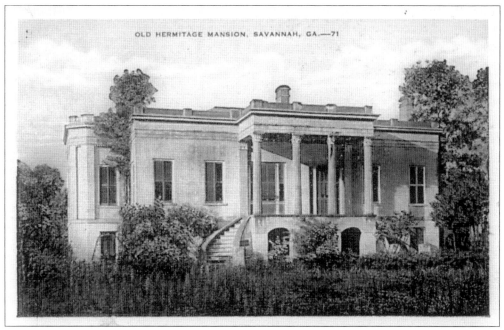

The Hermitage was an antebellum estate built *c.* 1830 by Savannah judge Henry McAlpin on the Savannah River. It was built largely of Savannah gray brick manufactured on the plantation site by slaves. When the Savannah Development Authority put the structure up for sale in 1935, Henry Ford purchased it. The Hermitage was torn down and the brick transported 20 miles to the Fords' Ogeechee River property just outside Ways Station/Richmond Hill.

Pictured is the idyllic setting for the Fords' house, featuring large live oak trees and an expansive view overlooking the Ogeechee River with the former rice marshes of the old Richmond plantation. Originally a crown grant to John Harn in 1748, the original tract was called Dublin. In 1821, the plantation was acquired by Mary Savage Clay and her son, Thomas Savage Clay. They named it Richmond, and the property remained in Clay family ownership for a century before being purchased by Henry D. Weed of Savannah, who subsequently sold the tract to Ford in April 1925. The Fords named their home Richmond after the old Clay plantation.

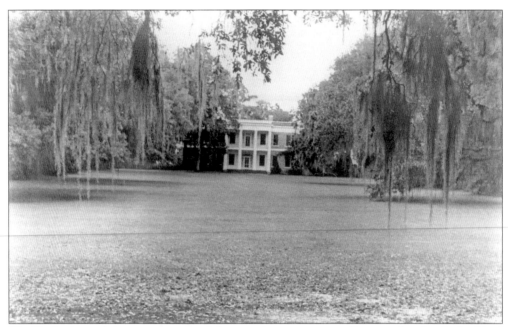

The Fords planned the construction of their residence in essentially every detail—the builders' model is on display in the Henry Ford Museum in Dearborn. The first floor of the house had 3,600 square feet, with another 3,330 square feet on the second story. Work was completed in 1936, and Richmond became regarded as one of the finest coastal Georgia residences.

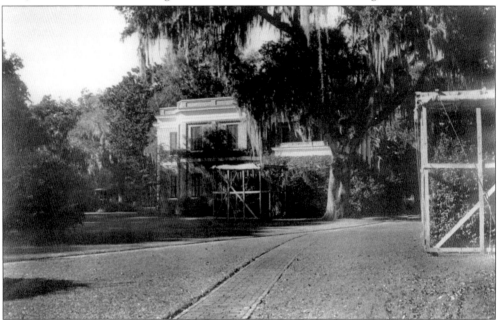

The Fords intentionally designed their home and its attendant landscaping to feature openness and to take advantage of the natural beauty of the site. As shown, the native live oaks were considered the most appealing feature of Richmond. In fact, the Fords did not want vehicle traffic near the front of the house—a paved walkway connected the front of the house to a circular driveway about 50 yards from the residence.

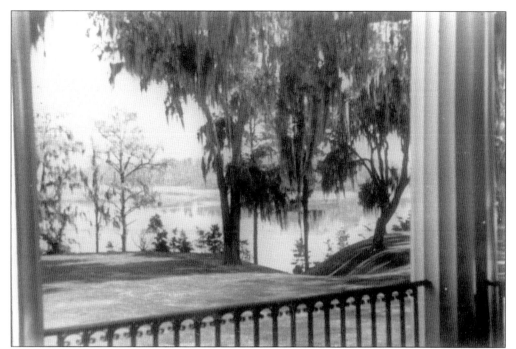

Moss-draped live oaks frame the view of the Ogeechee marshes from the rear of the Ford mansion. This scene has become a trademark image of the Henry Ford estate at Richmond Hill and has been reprinted many times in the literature about the area.

The landscaping and the access lanes from Bryan Neck Road (present-day State Highway 144) provided a picturesque approach to the Ford estate. Shown above is the tree-lined, oyster-shell drive to the main house. This road went by the restored house at Cherry Hill, the adjoining tract to Richmond, before winding its way to the Fords' residence.

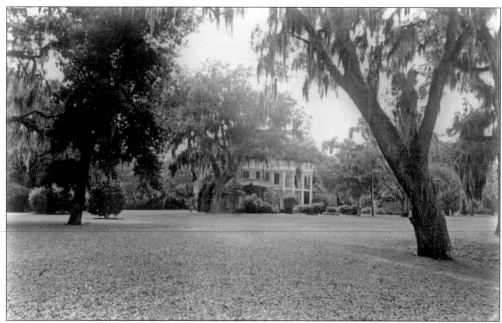

The expansive front lawn accentuated the main entrance to the Fords' residence. The refurbished, present-day Ford mansion continues to reflect the simple charm of the original 1930s house.

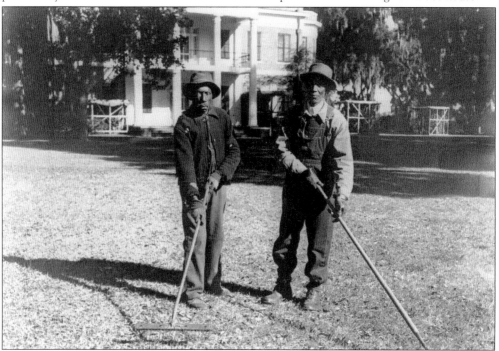

C. W. Alexander (left) and Ned Powell were two members of the Fords' staff of gardeners and groundskeepers at Richmond. Henry Ford was known for his fastidiousness and insisted on both the house and grounds being kept in an immaculate appearance. Other members of the grounds crew were Peter Williams, Fred Mitchell, and Tom Burke. All of these men were lifelong residents of the Ogeechee region.

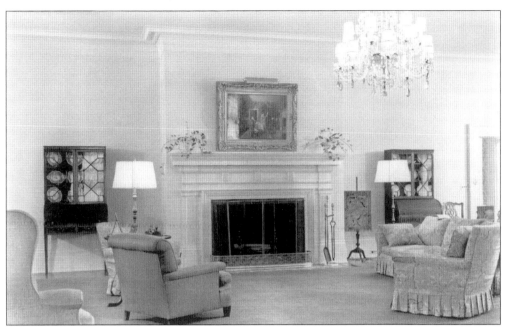

The living room of the Ford residence measured about 25 feet in width and 50 feet in length. The most striking feature of this and other interior views of the house was the simplicity the Fords incorporated into their surroundings. The habitability of the house was far more important than grandeur during their winter stays at Richmond.

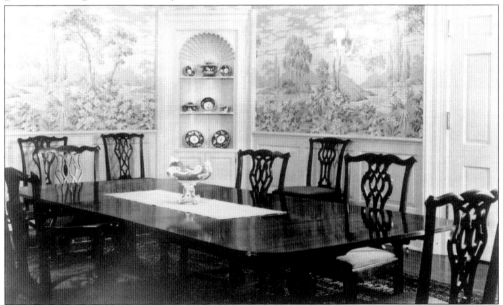

The dining room was a focal point when the Fords entertained. According to *The Henry Ford Era at Richmond Hill*, the memoir of Lucy and Leslie Long, Clara Ford entertained guests in February 1939 with a menu featuring "350 sandwiches consisting of shrimp salad, almond and celery, old English cheese, 100 toasted peanut butter and bacon, 100 rolled Virginia ham paste, 100 cheese biscuits, 150 cakes of sponge, Creole kisses and almond crescents," complemented by "salted peanuts, small cucumber pickles, mints, coffee and hot chocolate with whipped cream."

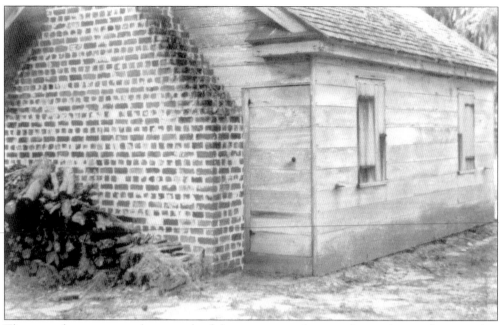

The oyster house was on the grounds of the estate near the powerhouse. It was of great utility to the Fords during their winter sojourns, as they held frequent oyster roasts, traditional to the Lowcountry at that time of year. Of special note was the sign over the entrance of this structure, spelled "AIGROEG," which created consternation on the part of visitors until someone ultimately solved the puzzle—the word was "Georgia" spelled backwards and was yet another Henry Ford touch.

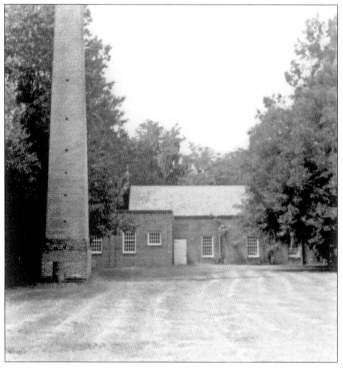

The powerhouse was a restored structure formerly used as a steam rice mill when Richmond was a rice plantation. At left is the tall, brick chimney, with the mill structure at right. Ford had two steam boilers installed. Power was supplied by the old rice mill engine that had been reconditioned at Dearborn. Leslie Long, in his memoirs, noted that the restored engine ran perfectly and was "the quietest running steam engine I have ever observed. You could stand within a foot of the flywheel and feel the breeze from it but you could not hear the engine running."

Three

AGRICULTURE AND INDUSTRY

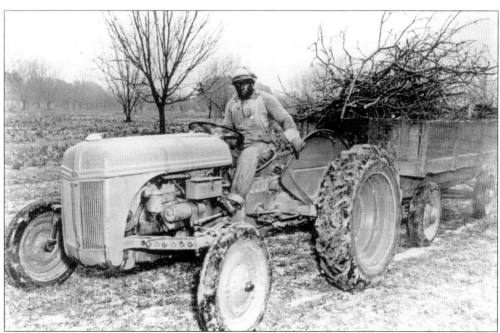

The reclamation of former rice fields on both sides of the lower Ogeechee River preceded the development of large-scale agricultural operations, particularly lettuce and other vegetables. Most of the rice fields had been abandoned since the 1880s. The reclamation work largely occurred on the former Cherry Hill and Richmond plantations, totaling about 500 acres of rice marsh. Shown above is a worker from Ford's Vallambrosa plantation on the Chatham County side of the river. It should come as no surprise that the workman is driving a Ford tractor. The scope of Ford's operations provided jobs for hundreds of Bryan and Chatham residents.

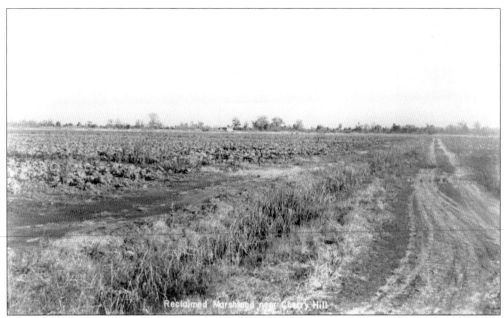

Pictured is part of the reclaimed rice marshes on the Ogeechee River at Cherry Hill. Fields were cleared of trees and brush and the old rice tide gates repaired to prevent the influx of brackish saltwater into the fields. Following that, the fields were sectioned off and experimental crops planted to assess the condition of the rich Ogeechee bottomland soils. Tests were done for acidity, phosphorous, nitrogen, and other elements to establish the degree of fertilization and nutrients needed before large-scale farming operations began.

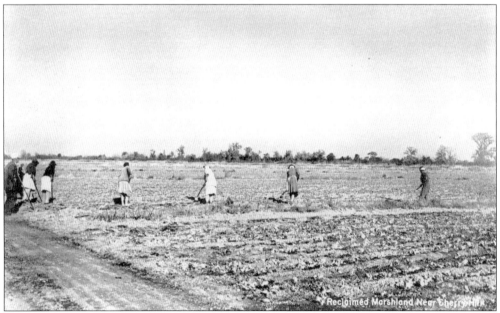

Workers cultivated iceberg lettuce along bedded rows after which, as demonstrated above, the lettuce plants were thinned by hoeing. In many respects this work was quite evocative of tending the former rice fields in earlier generations. As with lettuce, the earlier rice workers periodically thinned, weeded, and otherwise carefully nurtured the crop during the growing cycle.

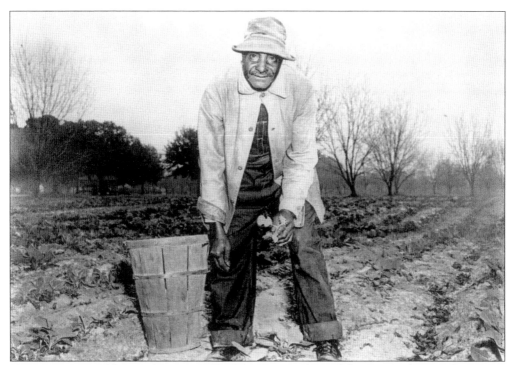

Harvesting vegetables on the various Ford farms was often a laborious, tedious task. Lettuce growing and the cultivation of other crops was very labor intensive, often reflecting the hard work conducted on the former rice plantation of the 19th century.

Interestingly several acres on the Ford farms were devoted to the cultivation of rice, using similar techniques employed by the planters of a century earlier, including the alternate flooding and draining of irrigated fields through a network of ditches, canals, and tide gates. Above rice straw is being baled and carted off following the late-summer threshing process after harvesting the crop. Much of the rice grown around Richmond Hill was sold locally in the Commissary and other stores.

Gated entrances to the fields provided access for farm workers. The fields and overall farm operations necessarily had to be fenced to prevent the incursion of wildlife, such as deer as other scavengers, which could seriously damage the crops.

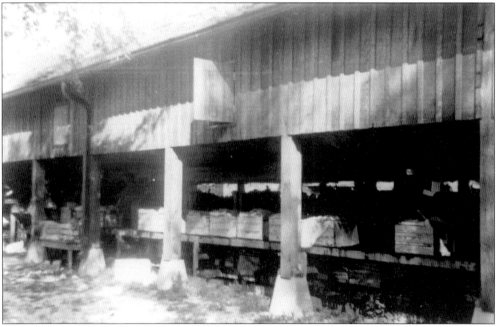

The processing of the lettuce crop was a complex effort. The packing shed pictured above featured both manual packing with that augmented by mechanized processes. Conveyor belts sent the picked lettuce through water sprayers for washing, after which the lettuce was packed in layers in boxes of ice. Wooden lids were nailed atop the boxes in preparation for shipping the boxes to the markets.

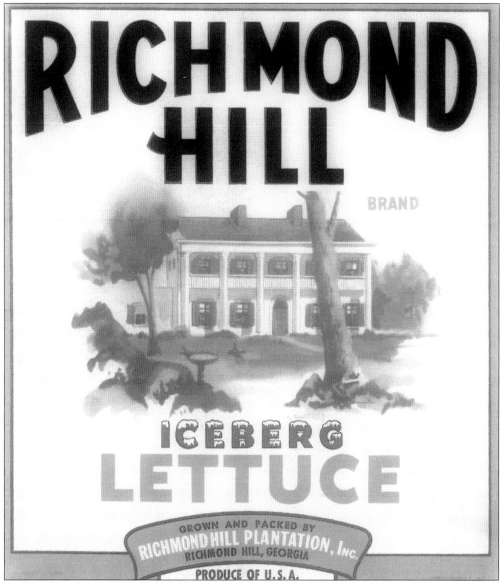

RICHMOND HILL

BRAND

ICEBERG LETTUCE

GROWN AND PACKED BY
RICHMOND HILL PLANTATION, Inc.
RICHMOND HILL, GEORGIA

PRODUCE OF U.S.A.

Richmond Hill lettuce came to be recognized as a very high-quality product. The excellence of the iceberg lettuce grown at Ford Farms was attributable to the rich soils, which were exposed to the brackish, slightly salty waters of the Ogeechee River. This label was utilized at the packing shed for shipments of lettuce to the produce market in Savannah for distribution along the U.S. East Coast.

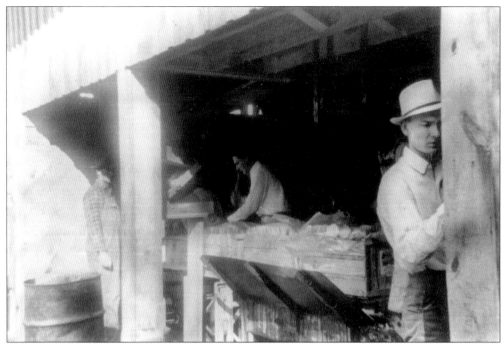

Leslie Long is pictured recording the amounts of packed lettuce preparatory to shipment to the produce market in Savannah. Long, in the memoir compiled by his wife, Lucy Bunce Long, and him, noted that he once assisted in the loading of 17 tons of lettuce on one tractor-trailer truck for shipment.

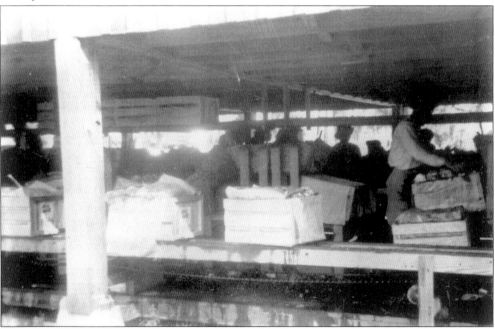

The packing of the lettuce into wooden crates was very systematic, involving a large number of workers. This operation moved with speed and efficiency—necessarily so in order to ensure that the lettuce be as fresh as possible when shipped.

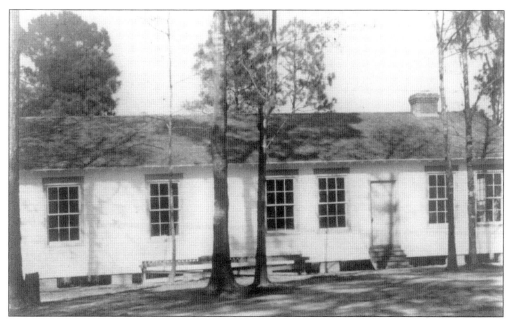

From the Research Laboratory, built in 1936, emanated much of the knowledge and expertise for the successful operation of Ford Farms. Research was coordinated in the structure by the director, Harry G. Ukkelberg, with assistance from chemists Frank McCall and Jack Oliver and technician Leslie Long. Soil testing and analysis was conducted at the lab in addition to experimentation in the conversion of farm products into materials that could be utilized in the automotive industry. Examples of this included rayon for tire cord made from local sweet gum and black gum trees, plastics made from corn cobs, and sawdust converted to use in the manufacture of engine parts.

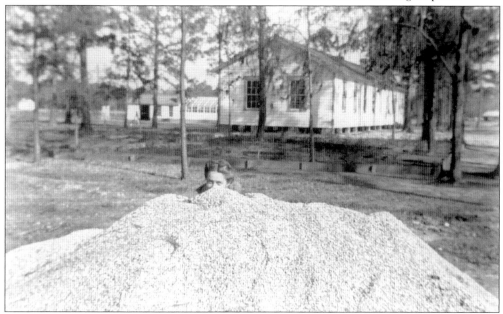

Edna Heron, a Richmond Hill school teacher, is pictured in this whimsical view taken in 1940 amid a pile of sawdust and wood chips at the Research Laboratory. The lab and the weather station buildings are in the background of the photograph.

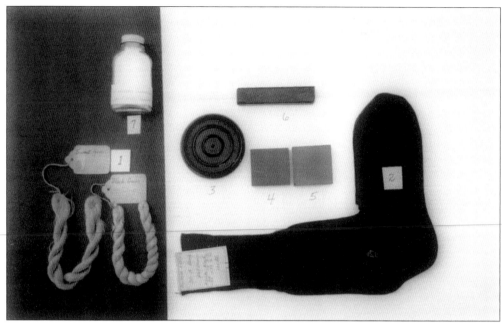

Research samples are shown, including at left rayon made from sweet gum and black gum trees around Richmond Hill and a vial of sweet potato starch used for a time as a substitute for corn starch in the manufacture of cloth and paper; the socks are of rayon made from sweet gum trees—Henry Ford liked to wear these types of socks to exemplify the experimental work being done at Richmond Hill. The other items are plastics made from corncobs and sawdust.

Farm livestock are pictured grazing at Cherry Hill plantation. The livestock operations were generally not extensive and were largely confined to local and domestic use in the Richmond Hill area.

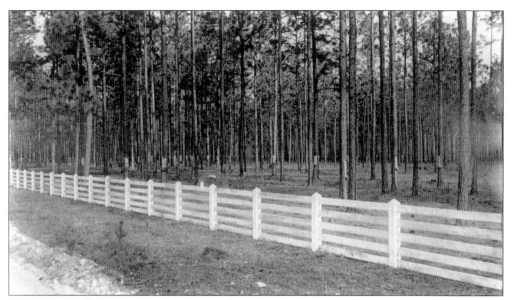

The tapping of pine trees to obtain gum (pine sap resin) for distillation into turpentine was a major component of the Ford plantation operations on Bryan Neck. The plantation had a large turpentine distillery for processing pine sap. Shown above are some of the thousands of pine trees that have been cut (hacked) then streaked for the placement of cups into which the gum drips during the warm-weather months. This pine forest was near Belfast, about 10 miles east of Richmond Hill.

Although many of the local trees were used to gather gum for turpentine, others were cut for saw timber to process into lumber. The gum was ladled from the tree cups into 50-gallon barrels then taken to the local still. In 1938, Ford built a turpentine distillery on Belfast Siding Road. The yield of turpentine and rosin from five 50-gallon barrels of gum was typically about 50 gallons of turpentine and four barrels of rosin. The distilling of turpentine was a major naval stores industry in Southeast Georgia from the 1870s until about 1960. Georgia was the world leader in the production of naval stores during much of this period.

UNION BAG & PAPER CORPORATION
WOOLWORTH BUILDING
NEW YORK CITY

Address Reply to:

WOODLANDS DIVISION
409 LIBERTY BANK BUILDING
SAVANNAH 5. GA.

Savannah, Georgia
September 11, 1944

Mr. J. F. Gregory,
Richmond Hill Plantation,
Ways Station, Georgia

Dear Mr. Gregory:

Mr. J. J. Armstrong, Manager of the Woodlands Division,
would like to see you Friday morning, September 15, and
arrange for settlement for the pulpwood cut at Richmond
Hill.

We will be at your office at 10:30 or 11:00 if this will
be a convenient time for you. If not, please let me know.
I can be reached through the Woodlands Division at 409
Liberty National Bank Building at Savannah. The telephone
is 3-7737.

Yours very truly,

A. E. Wackerman

AEW:j

1,725

Do you know that, in addition to the standard grades of grocery bags and sacks, Union's manufacturing facilities cover a complete range of "Specials"—from dainty transparent cellulose bags to rugged multi-wall sacks. "If it's a machine-made paper bag, call Union".

As exemplified by this business letter, the cutting of timber on the Ford lands was a prime component of the lumber and naval stores activity on Bryan Neck. Union Bag and Paper of Savannah, founded in 1934, became one of the nation's leaders in the processing of pine pulp into paper products. Southeast Georgia pine timber was greatly in demand for operations such as Union Bag, and lower Bryan County provided much of the pulp timber, largely from Ford-owned lands.

Felling a tree in the pine forests on Bryan Neck required skill and expertise on the part of local sawyers. Timbering in the Richmond Hill area was an almost constant activity from the time the first settlers came into the neck in 1734.

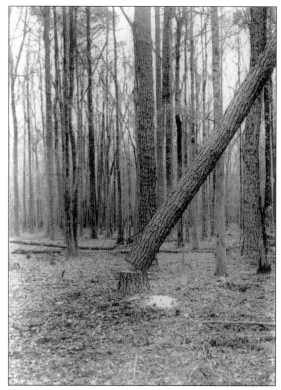

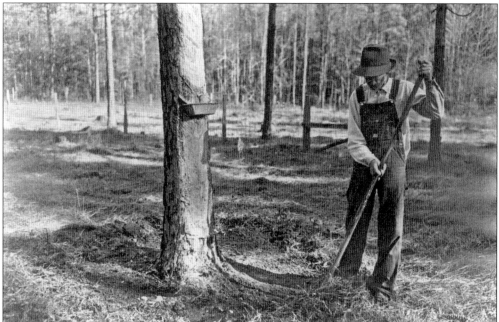

Here a forest worker clears an area from around a pine tree to reduce loss of the tree because of either wildfire or prescribed burning. Burns of the forest ground cover were periodically conducted to reduce the incidence of forest fires, which were a natural occurrence usually caused by lightning strikes during summer thunderstorms.

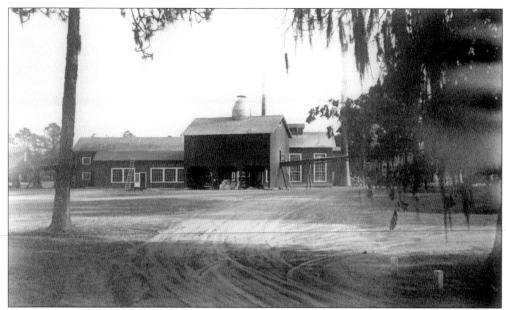

The Ford sawmill was in Ways Station/Richmond Hill just off the Bryan Neck Road near the Seaboard Railroad tracks. Due to the demand for pine lumber during World War II for the Savannah shipyards and the construction of nearby Camp Stewart, the mill's peak output was about 90,000 board feet per day. Two large steam boilers burned sawdust to generate power for the mill's engines and saws. Two other boilers burned wood chips from the planing mill and cabinet shop, thus powering a generator that provided electricity for the nearby Industrial Arts and Trade School.

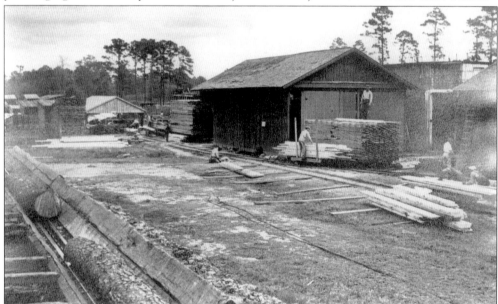

Here processed lumber is stacked in the sawmill yard preparatory to distribution to various construction projects. Most of the structures around Richmond Hill, including residential housing for Ford's employees (about 235 houses) and various community buildings, were constructed from lumber supplied by the local sawmill. These included the Community House, Industrial Arts and Trade School, Martha-Mary Chapel, George Washington Carver School, and the Commissary.

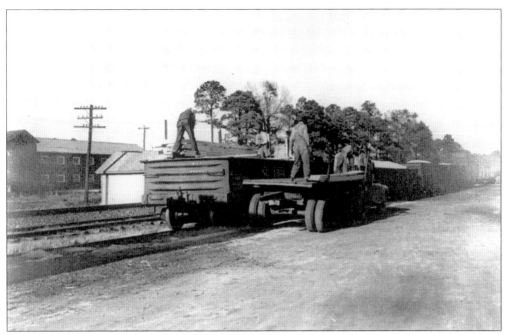

The processed pine lumber not used for local purposes was usually shipped by rail, above, to Savannah and, just before and during World War II, to Camp Stewart. The Ford sawmill was a continuation of sawmilling work that reached its peak of activity 40 years earlier at the Belfast mill on the Belfast River east of Richmond Hill.

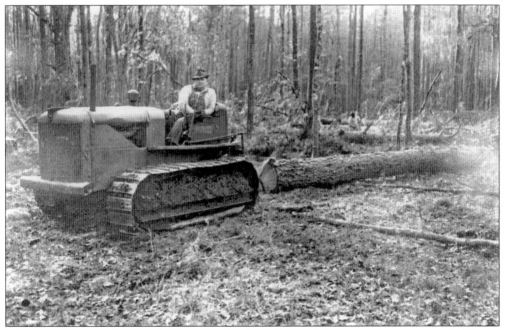

The sawmill acquired its supply of pine timber from Bryan Neck and, before the arrival of Camp Stewart in 1941, from areas west of present-day Interstate 95. Trees were cut near the ground, the trunks were trimmed of branches, and then, through the use of bulldozers as shown above, the logs were dragged to a loading area, where trucks transported the timber to the sawmill.

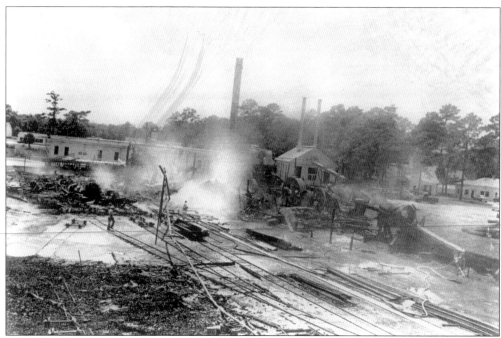

An accidental fire destroyed the sawmill complex in 1950. Fires were not uncommon to sawmills in Southeast Georgia. The highly flammable pine timber and lumber were often described as "wooden blowtorches" if they took fire. Many mills burned because of accidental sparks from the generating equipment, friction from the gang saws, or carelessness on the part of workers. The Richmond Hill sawmill was not rebuilt, since the Ford operations on Bryan Neck were winding down.

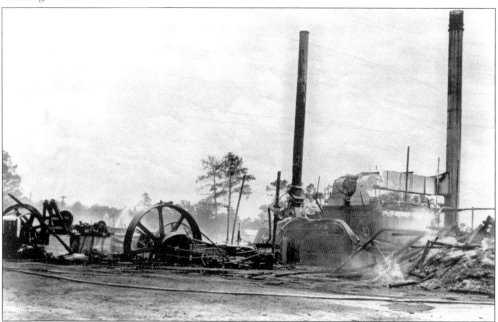

The aftermath of the fire that destroyed the sawmill reveals the charred and mangled remains of the steam powerhouse and generating equipment that operated the gang saws.

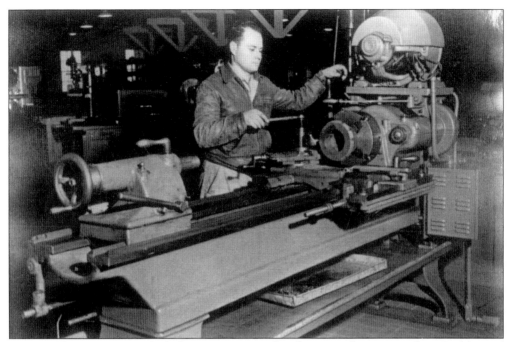

Fred Bashlor is operating the lathe equipment in the plantation farm repair shop. Bashlor and many others received their industrial training at the trade school begun by Ford in Richmond Hill in the late 1930s.

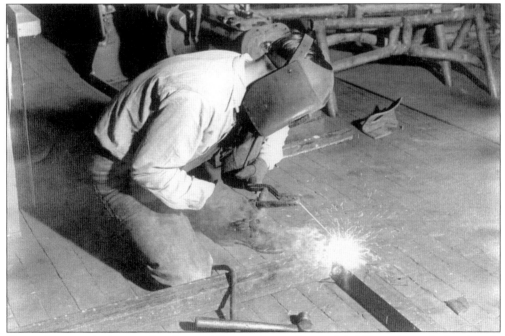

Here a farm repair-shop worker does welding work, another useful skill taught at the local trade school. Many of the young people of the Richmond Hill area learned their skills at the trade school and utilized them in the industrial mobilization during World War II, particularly at the Savannah shipyards that contributed a large number of Liberty military transport ships.

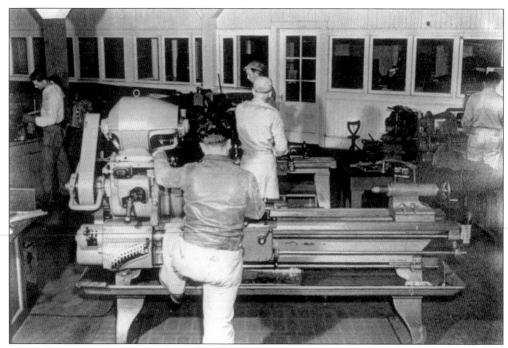

The lathe training section at the Industrial Arts and Trade School taught these skills to locals. People in the photograph include Jasper Davis, Fred Bashlor, Bo Smith, and Fulton Bell.

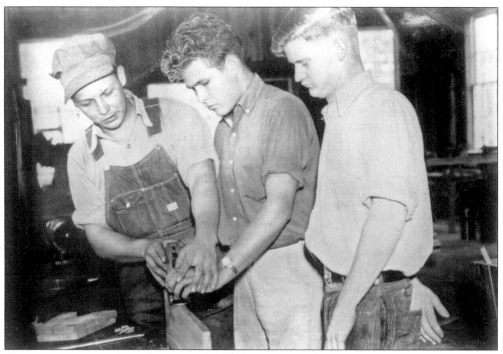

Two young men are shown being taught the finer points of machinery operation during shop classes at the trade school.

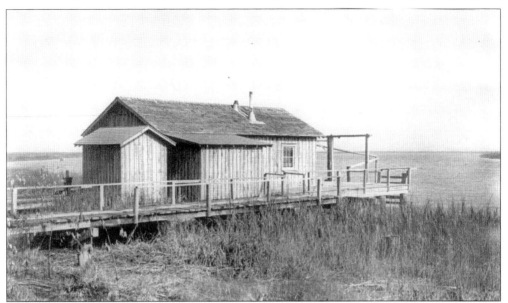

Oyster harvesting on the South Carolina and Georgia coasts had been an economic mainstay since the 1880s. Georgia's tidal waters between the barrier islands and the mainland were some of the richest oyster grounds in the world. Henry Ford began an oystering operation and built this shucking house on the Kilkenny River. Local shuckers processed the oysters as they were brought in by wooden bateaux from the beds during the fall and winter months. Fresh local oysters were a popular commodity at the plantation Commissary.

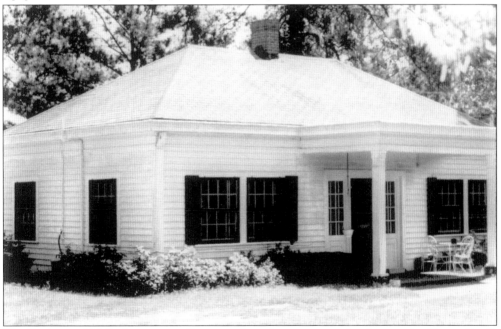

The Richmond Hill plantation office was the administrative focal point for Henry Ford's operations on Bryan Neck. Here, in this modest five-room structure, the plantation superintendent and the bookkeeper had offices. The payroll office and the telephone exchange were also in the building.

The business of Richmond Hill plantation carried on even after the death of Henry Ford in 1947. The voluminous paperwork generated by the plantation office all found its way to the Ford headquarters in Dearborn. The Ford Archives in Dearborn are the repository for all the records, documents, and administrative minutiae of the Richmond Hill plantation during the span of the Ford activities on Bryan Neck, 1925–1951.

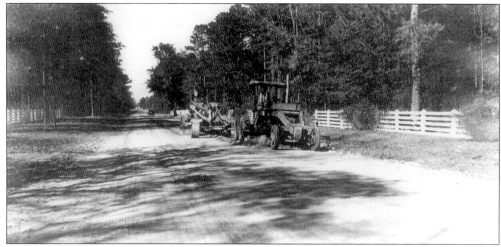

Prior to the 1950s, all the roads east of Richmond Hill were either sand roads or shell roads. Employees of Richmond Hill plantation conducted road maintenance as shown in this scene along Bryan Neck Road east of town.

Four

PLANTATIONS RESTORED

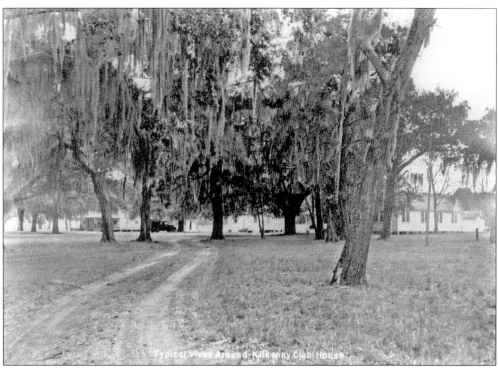

Commensurate with the various agricultural and naval stores endeavors around Richmond Hill during the 1930s and 1940s, the Fords undertook the rehabilitation of a number of the old antebellum plantation homes on Bryan Neck, many of which had fallen into varying states of disrepair. During Kilpatrick's raid on Bryan Neck preceding the investment of Fort McAllister in December 1864, much of the rice plantation infrastructure had been destroyed. Pictured *c.* 1940 are the grounds of the former Kilkenny cotton plantation on the banks of the tidal Kilkenny River overlooking Ossabaw and St. Catherines Islands.

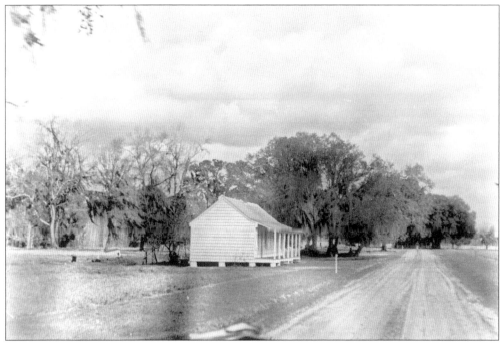

This restored structure at Cherry Hill plantation was once a slave dwelling during the plantation's heyday as one of Richard J. Arnold's rice plantations. The sandy lane passing in front of the little house leads to the main (overseer's) house at Cherry Hill.

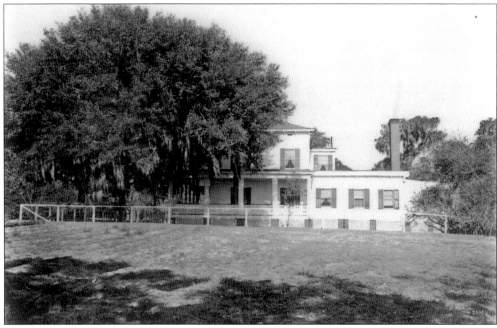

This view depicts the Cherry Hill overseer's house as it appeared prior to Ford's restoration. The original house on the site burned during the Civil War and was rebuilt in 1874 by William Eliot Arnold, a son of R. J. Arnold who had resumed the cultivation of rice at Cherry Hill. Another view of the house before restoration appears on page 13 of this volume.

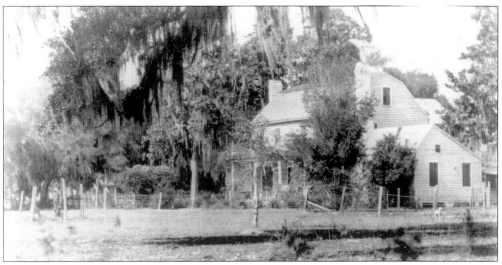

This is Strathy Hall as it appeared before restoration in 1940. The house was built in 1838 by the owner of Strathy Hall plantation, George Washington McAllister, one of the prominent rice planters of the Ogeechee River basin. McAllister died in 1850, leaving the house and his plantation holdings to his son, Joseph Longworth McAllister. Strathy Hall was originally a 1755 crown grant to Capt. James Mackay, who lived on the site until his death in 1785. G. W. McAllister acquired the tract in 1817. His daughter, Matilda Willis, married Thomas Savage Clay of neighboring Richmond plantation. In 1878, Strathy Hall was acquired by a son of the Clays, Robert Habersham Clay, whose widow, Eva Mills Clay, sold the property to Henry Ford in 1925. Now on the National Register of Historic Places, Strathy Hall was further restored by former owners Mr. and Mrs. Neill Baylor.

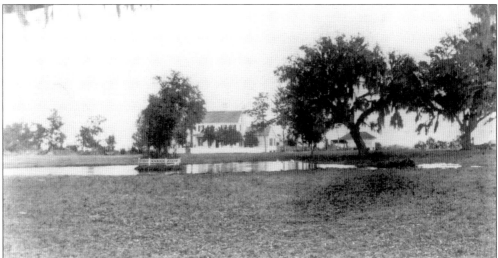

Leslie Long, coauthor of *The Henry Ford Era at Richmond Hill*, notes that this view is probably not Strathy Hall because of the configuration of the oak trees and the pond in the foreground. However, there are aspects of this house's architecture that makes it an intriguing possibility that it is indeed Strathy Hall. The open and clear area behind the house is evocative of the Ogeechee River rice marshes, which in truth are only a short distance from the dwelling. If this is indeed Strathy Hall, the picture was likely taken after the home's restoration by Ford. Compare with the picture of Strathy Hall above.

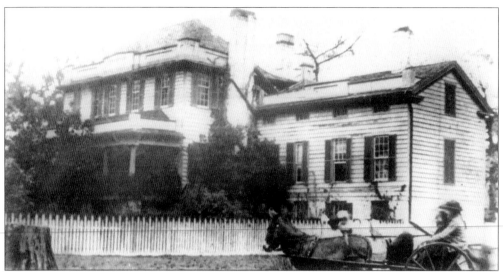

The Whitehall plantation was the winter residence of Richard James Arnold and his family of Providence, Rhode Island, during the years before and after the Civil War. Arnold had begun to acquire his Bryan Neck lands upon his 1824 marriage to Louisa Caroline Gindrat. Arnold was the largest land and slave owner in Bryan County. Later Arnold (who died in 1873) turned his plantations over to his sons, William Eliot Arnold and Thomas Arnold. Neither was as efficient at farm management as their father, and the Arnolds' lands were sold to satisfy financial encumbrances. Whitehall was purchased in 1877 by George Appleton, husband of R. J. Arnold's granddaughter, Luly Arnold. Whitehall was a total loss in a 1914 fire and was never rebuilt. The photograph depicts the house before its loss, well before the arrival of Ford on Bryan Neck.

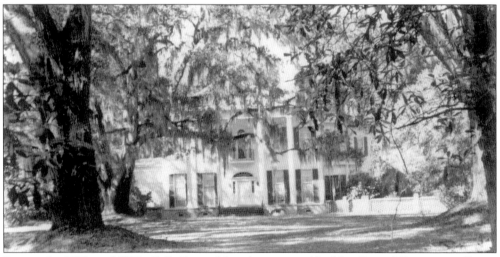

During the 1920s and 1930s, Folly Farms (above) was owned by Mrs. Samuel Pennington Rotan of Pennsylvania, who was involved in the effort to improve medical care for the indigent people around Ways Station. She became friends with Henry and Clara Ford, who provided medical facilities at Ways to amplify the program begun by Mrs. Rotan. Folly Farms was originally known as Myrtle Grove and was one of the Richard Arnold properties before the Civil War. Arnold built the house in 1850 as a wedding gift for his daughter. After the outbreak of World War II, Mrs. Rotan sold Folly Farms. The home, adjacent to the Whitehall tract, came into possession of Mr. and Mrs. Walter Meeks, who have extensively restored it over the succeeding years.

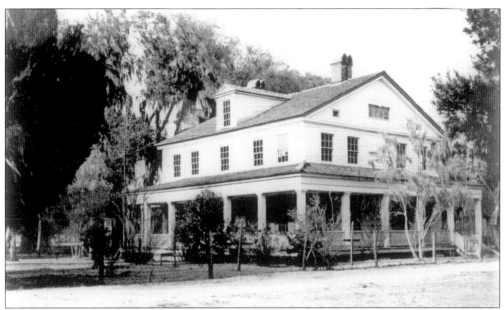

Cottenham was toward the lower end of Bryan Neck on Red Bird Creek south of Fort McAllister. It was another of the properties acquired then restored by Henry Ford during his sojourn in Richmond Hill. Cottenham was a Sea Island cotton plantation prior to the Civil War. When Ford had the Community House built in Ways Station in 1936, he had it designed after the Cottenham house. The photograph above was taken in 1935.

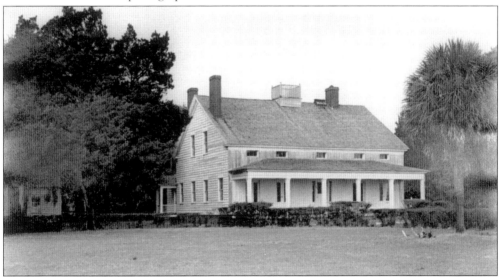

Another tract acquired by Ford was Kilkenny, on the Kilkenny River on the lower end of Bryan Neck overlooking Ossabaw Sound. The former Kilkenny Club building, above, was restored. Kilkenny was originally a crown grant to Thomas Young, whose heirs sold it to Charles W. Rogers Jr. of Sapelo Island in 1836. Rogers eventually became the largest Sea Island cotton grower on Bryan Neck with his expanding Kilkenny and adjoining Lincoln operations. Rogers built the plantation house c. 1845. Kilkenny passed through a succession of postbellum- and early-20th-century owners before being acquired by the Kilkenny Land and Cattle Company in 1918, which conveyed it to Ford in 1930.

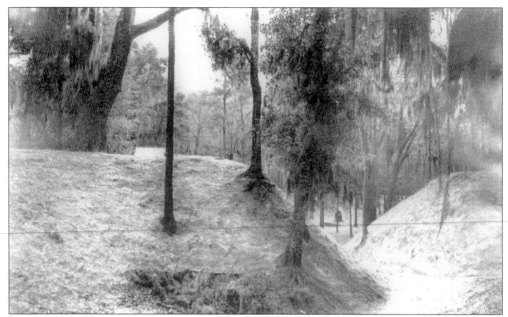

Fort McAllister was the scene of some of the intense military and naval activities of the Civil War in Georgia but was little more than a ruin when the fort and its Genesis Point tract on the Ogeechee River were acquired by Ford. The photograph reveals the appearance of the fort prior to restoration efforts by Ford. The Confederate earthworks are seen as overgrown with trees and brush after the years of disuse of the site.

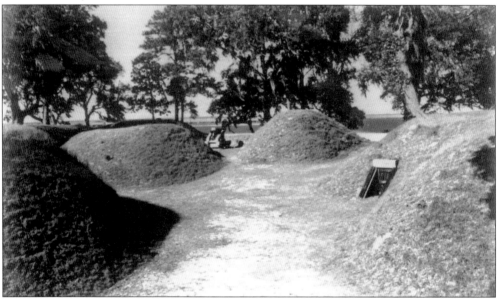

Following Ford's restoration, the earthworks and parapets of Fort McAllister had much the same appearance as they did during 1862–1865. The restoration was based on extensive historic research at the Georgia Historical Society in Savannah along with use of old records and Civil War–era photographs. In 1951, the Genesis Point property, including the restored fort, was sold to International Paper Company, which subsequently deeded the site to the State of Georgia. Fort McAllister is now a historic public park and campground.

Five

REMEMBERING THE PEOPLE

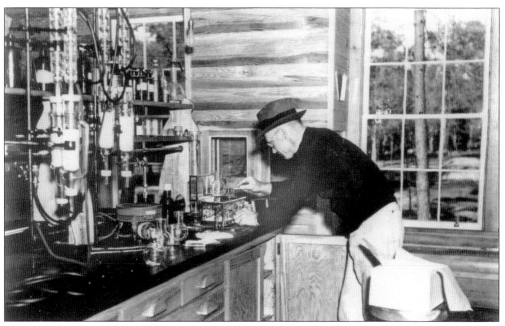

The period from 1925 to 1960 saw the establishment of many of the families in the area whose roots are still in the Richmond Hill community in the 21st century. One of those who came with Henry Ford was Harry Gilbert Ukkelberg, shown working in the Ford Research Laboratory at Richmond Hill. Ukkelberg was an agricultural scientist arriving at Richmond Hill plantation in 1936 to head the agricultural experiment station and research facility. One of his young protégés from 1938 onward was Leslie Long, who became an outstanding scientist and educator in his own right in subsequent years and a major contributor to preserving the Henry Ford legacy in Richmond Hill.

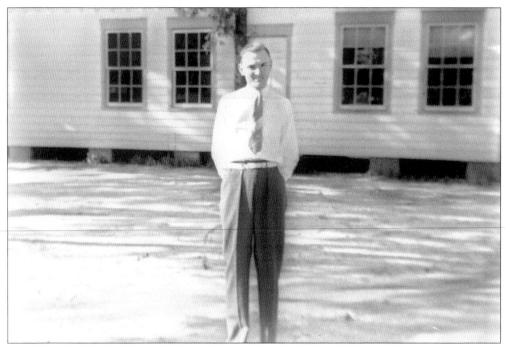

Franklin Leslie Long is shown shortly after he came to Richmond Hill in 1938 to work at the Ford Research Laboratory. Long met Lucy Bunce when she arrived in 1940 to teach school. They were married in Richmond Hill three years later. The Longs left Richmond Hill when the Ford estate sold its Bryan County properties in 1951. After fulfilling careers in education, they returned in retirement to their home on the Lincoln River near Richmond Hill in 1982.

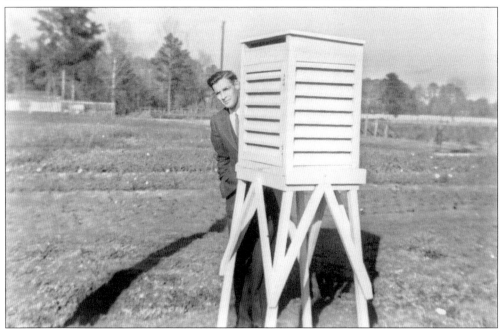

Leslie Long is shown c. 1942 collecting data recorded at the weather station near the greenhouse and the Ford Research Laboratory.

In 1938, Bascom Mehaffey came to work for Ford Farms/Richmond Hill plantation, where he was in charge of the garage and all mobile and heavy-equipment operations. He had been associated with Ford since 1924. Mehaffey served the Fords in his specialty until the plantation's sale in 1951. According to Leslie Long, at the peak of operations in the late 1940s, Mehaffey was responsible for no less than 55 trucks and cars, 18 Ford-Ferguson tractors, 12 Fordson tractors, and 10 school buses, among other equipment.

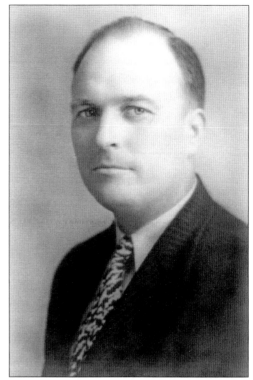

Ella Reed Sams (left), popularly known as "Nurse Reed," was one of the mainstays of the Ways Station medical clinic. She lived in Savannah and drove to the clinic in Richmond Hill each day. Here she is checking the pulse of Kelly Baldwin.

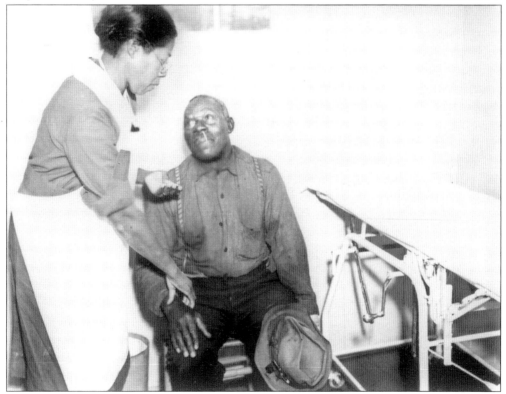

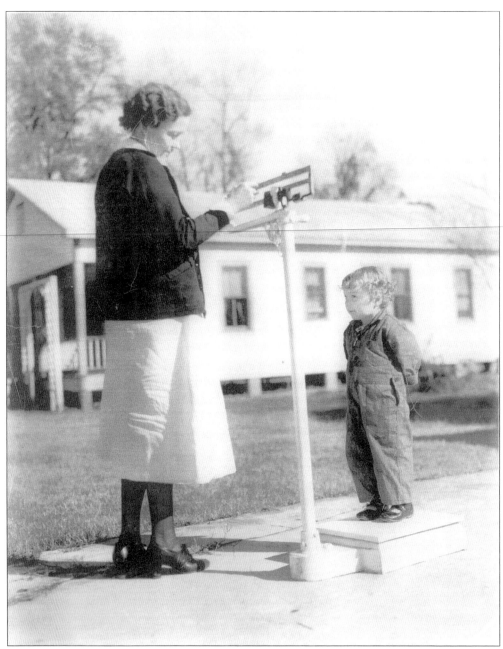

Head Nurse Constance Clark is pictured checking the weight of a young lad at the Richmond Hill medical clinic. Originally established by Mrs. Samuel Rotan, the clinic was financially supported by Henry and Clara Ford. Clark was hired by Mrs. Rotan in 1930 to provide the free health care at the Ways Health Association. The clinic was first located near the site of the Community House building and then moved near the Atlantic Coast Line railroad track in 1936. Nurse Clark became Ford's employee when he assumed operation of the clinic in 1935.

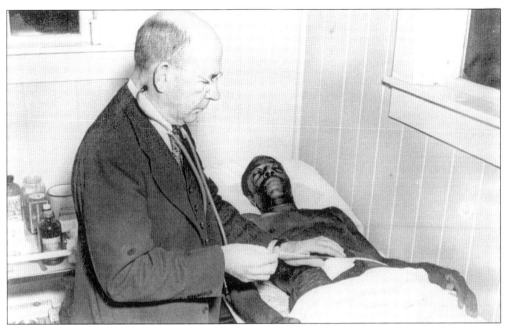

Dr. C. F. Holton of Savannah came to the clinic every Thursday (more frequently if he was needed) and administered medical care to local patients. Henry Ford provided the funding for Holton's medical service for the people of Richmond Hill in the 1930s and 1940s. All Ford employees were treated free of charge and received free medicine as well. Many non-employees were also treated for free if they could not afford to pay.

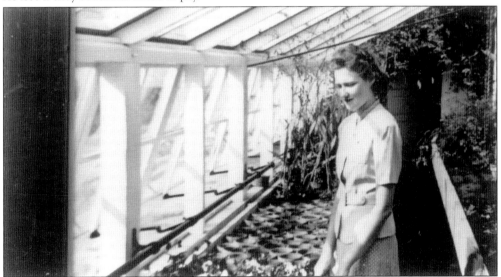

Lucy Bunce, pictured viewing plantings in the Ford greenhouse, arrived in 1940 to teach mathematics and science at Richmond Hill High School. Lucy Bunce became interested in the history of the area and began researching and collecting material on all the plantation tracts of Bryan Neck. She became one of the leading authorities on the history of Bryan County. She met Leslie Long, and they were married in 1943 in the Martha-Mary Chapel. The Longs were married for 57 years before the death of Leslie Long in 2000. Long was followed in death by Lucy in 2004. They were both born in 1918.

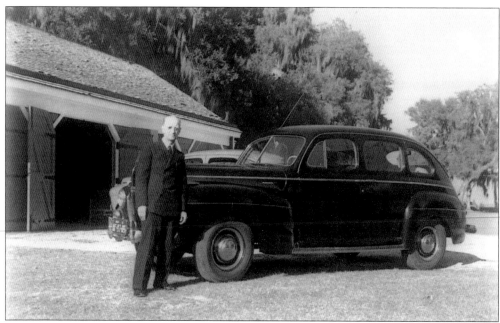

Both Mr. and Mrs. Ford had chauffeurs during their seasonal visits to Richmond Hill. Rufus Wilson was Henry's chauffeur, while Robert Rankin (pictured above) carried out similar duties for Clara. When the Fords rode together, it was usually in the Lincoln shown in the photograph, with Rankin at the wheel.

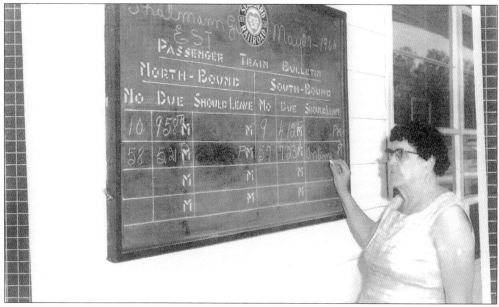

Vera Hobbs was the stationmaster and agent for the Seaboard Railroad depot in Richmond Hill. As shown on the schedule board, there were two northbound (to Savannah) passenger trains daily and two southbound (to Jacksonville) trains. Hobbs's sister, Edith Hobbs, was employed at the local post office. Most of the outgoing mail from Richmond Hill in the 1930s and 1940s went out on the trains that passed through; thus the two Hobbs sisters played important community roles and provided valuable services.

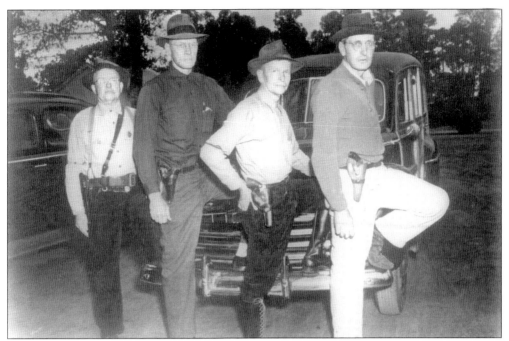

The Richmond Hill "Woods Riders" were employed by the Ford plantation to protect the wildlife on Bryan Neck. They typically patrolled the backwoods after dark keeping alert for illegal hunters, particularly those who hunted deer with bright lights. These men were deputized by Bryan County and had arresting authority. Pictured from left to right are Enoch Dukes, Tom Darieng, Rad Davis, and Buck Ellis. Another of their duties was the confiscation of illegal moonshine stills.

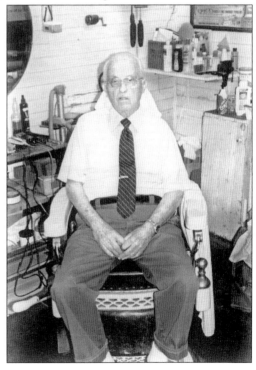

Bailey Carpenter operated the only barber shop in Ways Station when Henry Ford arrived on the scene in 1925. His shop was located at the Cross Roads, where Highway 17 and Bryan Neck Road (State 144) intersect. Carpenter cut Ford's hair on a regular basis when he was in Richmond Hill. Leslie Long relates the story that the usual cost of a haircut in the 1930s was about 35¢, but on the first occasion he cut Ford's hair, the auto maker paid Carpenter $10—which was equal to a month's rent for Carpenter at the time. Later Ford moved Carpenter's shop to a location closer to the Ford residence and not only paid the rent on the building but bought Carpenter a new barber chair and other fixtures for his shop.

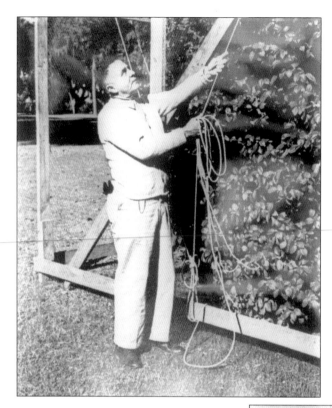

Marvin Sharpe handled the caretaking duties for the Ford residence, overseeing the grounds and building maintenance year-round. His role was especially valuable during the time the Fords were away. Sharpe is shown preparing protective coverings for the Fords' plants and shrubbery to prevent their loss during occasional winter freezes.

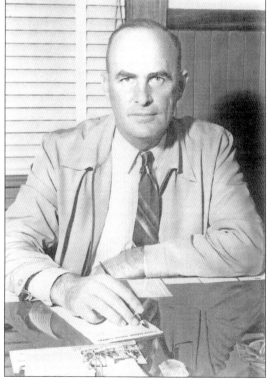

In early 1946, Mrs. Ford terminated the employment of Jack Gregory as superintendent of Richmond Hill plantation. As Gregory's replacement, the Fords brought in Ray Newman (pictured here) from managing the Fords' farming operations at Dearborn. Newman managed the Richmond Hill operations from April 1946 until 1951, at the conclusion of the sale of all of the Fords' holdings in Bryan and Chatham Counties, mostly to International Paper.

Six

AFRICAN AMERICANS ON BRYAN NECK

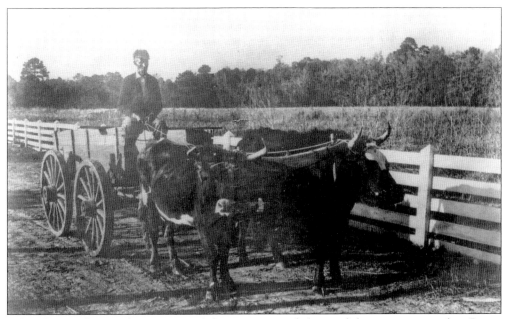

After the Civil War, the majority of the emancipated slaves of the area remained in Bryan County. During the 1880s and 1890s, settlements of African Americans began to be formed in the vicinity of Ways Station, often near the two railroads that passed the section. The communities included Daniel Siding, Brisbon, Cherry Hill, Rabbit Hill, Port Royal, and Oak Level. Some of these settlements were on, or near, the sites of the former rice and cotton plantations. The image above of John Harris and his oxen on Bryan Neck Road is evocative of the times when local African Americans were beginning to establish their own identity and a permanent sense of place in the Bryan Neck section.

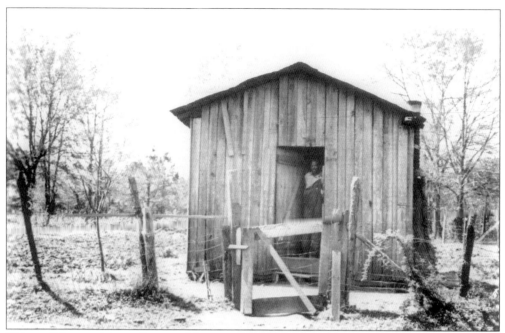

This small frame cabin is reflective of the impoverished conditions prevailing in lower Bryan County in the early 20th century. Many African Americans in the area lived in simple dwellings and were often self-sustaining by growing most of their own food while obtaining meat, fish, and shellfish from the abundant tidal waterways and forests. The man in the doorway is unidentified.

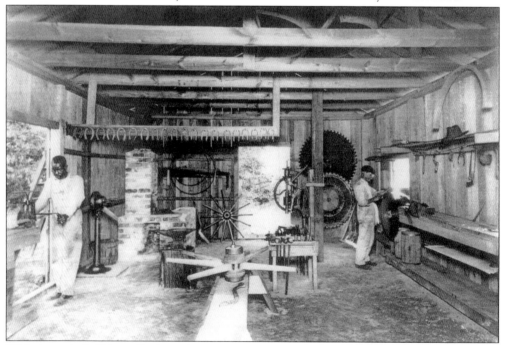

With the arrival of Henry Ford, employment opportunities for local blacks rose considerably. Here Lonnie Patterson, a blacksmith (at left), is working metal. Leslie Long noted that Patterson was the first black man in Richmond Hill to purchase a new automobile (in 1936).

Julius Hammock (center) lived in the Brisbon community and was reared in the Boles household. Pictured here at age 16, Julius was a water boy on the Ford plantation, working in various sections of the farm fields taking water to the workers. The two other men are unidentified.

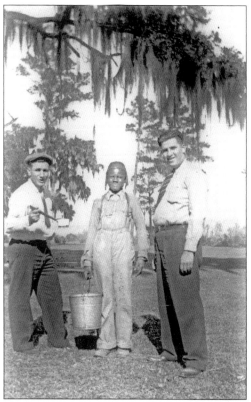

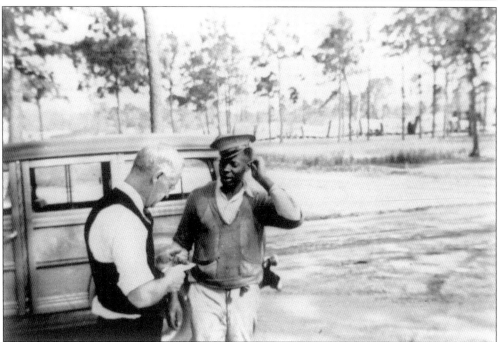

Steve Screven worked as a member of the labor crews on the Ford plantation. He is pictured here receiving his wages from plantation superintendent Jack Gregory.

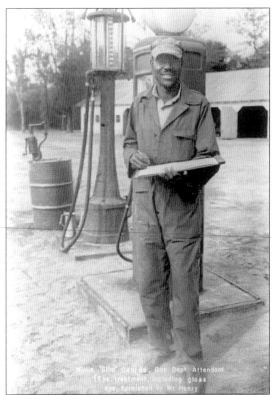

Willie George was the attendant at the gas fueling facility on the Ford plantation. Leslie Long notes that George had a serious eye problem and that Henry Ford paid for George's treatment to surgically remove the eye and replace it with a glass eye.

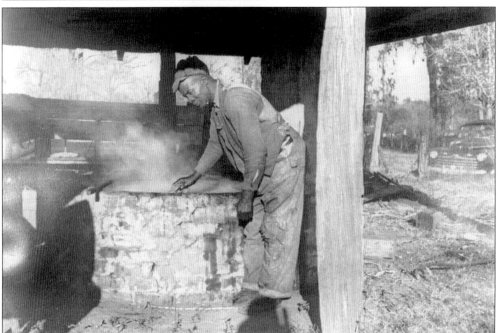

London Harris was one of those local residents in the Ways Station area who did not sell their land to Henry Ford. Harris grew sugar cane for a profit and is shown here boiling cane juice to make syrup.

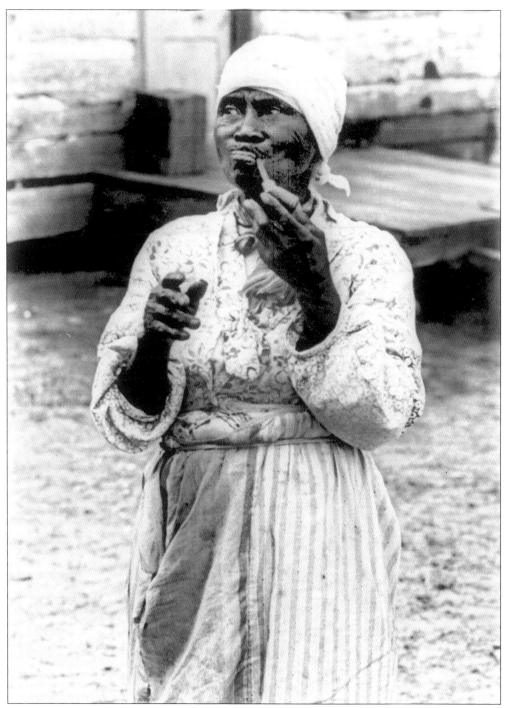

"Old Aunt Jane," born a slave on the Pierce Butler rice plantation in McIntosh County, lived in Darien, about 40 miles south of Richmond Hill. Henry and Clara Ford met her on a visit to Darien and paid for Nurse Reed from the Ford Clinic in Richmond Hill to visit her once a week. The Fords also built Aunt Jane a new house in Darien, another example of how they consistently helped impoverished African Americans in the area.

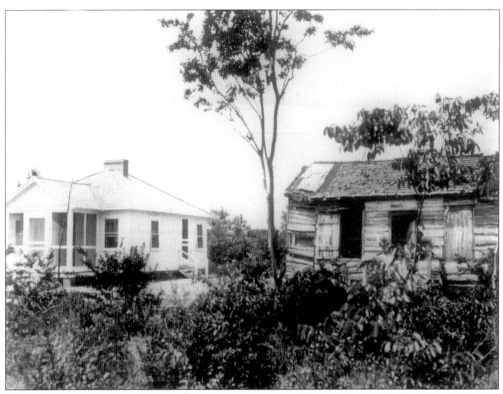

The new house the Fords built for Aunt Jane is shown in 1942 adjacent to Jane's former residence. After the death of Aunt Jane, and following the deaths of Henry and Clara Ford, the new cottage was purchased by H. G. Cooper, formerly the principle at George Washington Carver School at Richmond Hill. Following his career at Carver School, Cooper lived in Darien and owned a prosperous mortuary business for many years.

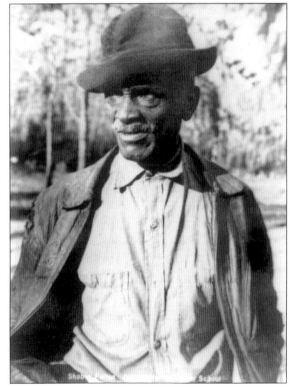

Shobie Fulton was the janitor at George Washington Carver School. Leslie Long remembers Fulton as a very personable man who was extremely popular. "He was somewhat of a comedian," Long recalled in his memoirs.

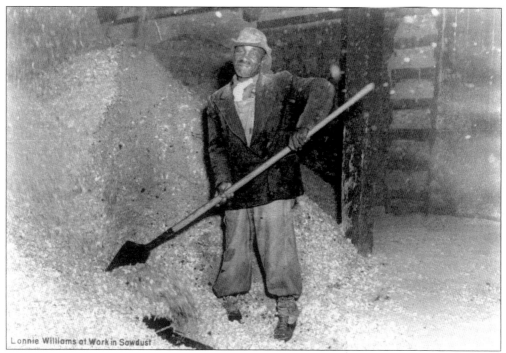

Lonnie Williams at Work in Sawdust

Lonnie Williams is hard at work in the Ford plantation sawmill. The sawdust was recycled for use in the agriculture laboratory in the development of a variety of products, including plastics.

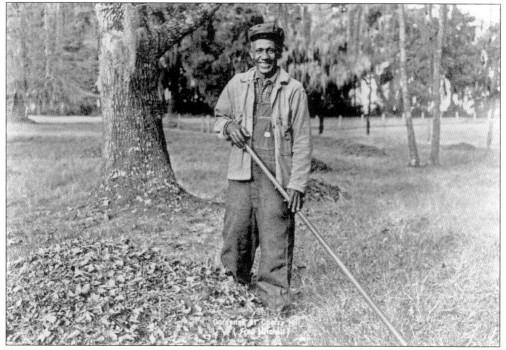

Fred Mitchell is shown raking leaves at Cherry Hill not far from the Fords' Richmond residence. The Fords utilized a large staff of local employees for the maintenance of their buildings and groundskeeping. The lawns at Richmond were always immaculate.

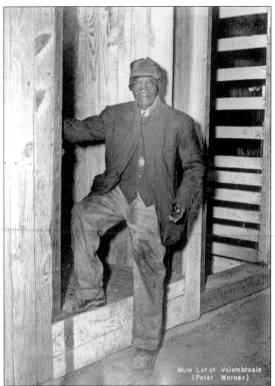

Peter Warner worked with the mules at Ford's Vallambrosa farming operation. Vallambrosa was a large former rice tract on the Chatham County side of the Ogeechee River directly across from Silk Hope, Cherry Hill, and Richmond on the Bryan County side.

Mule Lot at Valembrosia
(Peter Warner)

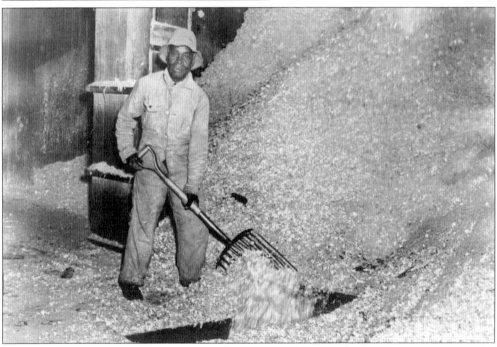

The Ford plantation sawmill was one of the largest employers of Africans Americans in the Richmond Hill area. Here John Turner is seen working in the large sawdust pile produced by the processing of lumber at the mill.

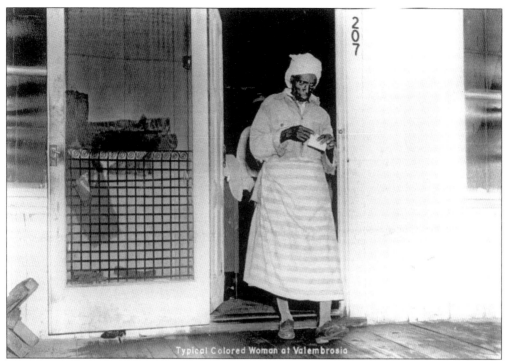

Typical Colored Woman at Valembrosia

An unidentified black woman is seen here emerging from one of the dwellings at Vallambrosa plantation.

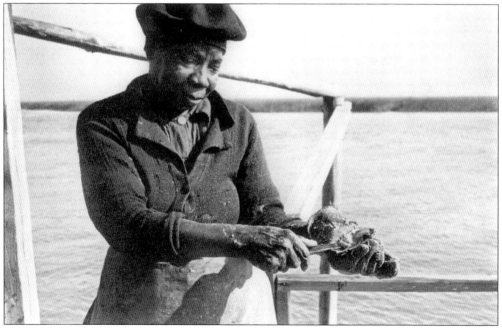

This unidentified woman is demonstrating an art practiced almost universally by both blacks and whites in the Georgia tidewater region—shucking oysters. She is utilizing a special, heavy-duty oyster knife to pry open the oyster. Oyster shuckers necessarily have to wear thick gloves to help prevent cutting their hands on the sharp oyster shells.

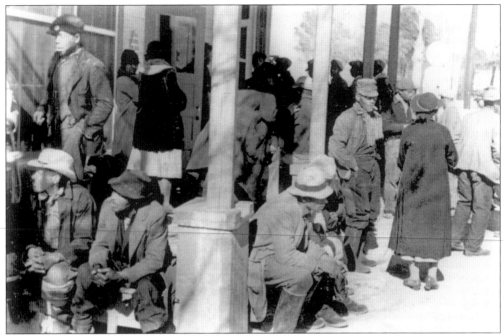

Gordon Butler's store by the Seaboard Railroad was an important gathering place for local African Americans, particularly on Friday afternoons, when workers at the Ford plantation went there to receive their pay. Later Henry Ford bought Butler's store, had it torn down, then built a new Commissary directly across the road, a building which is still in use today.

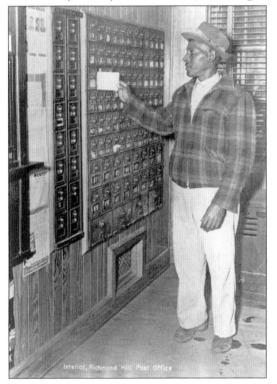

The Ways Station/Richmond Hill post office was located inside Butler's store by the railroad, where much of the mail arrived from passing trains. It was from here also that Ira Casey Sr. delivered mail to the rural sections of Bryan Neck. As shown above, some local patrons had their own mailboxes at the post office. When the store was torn down, Ford had a nearby, one-room school building remodeled as the post office for Richmond Hill.

Seven

A VILLAGE AND
A COMMUNITY

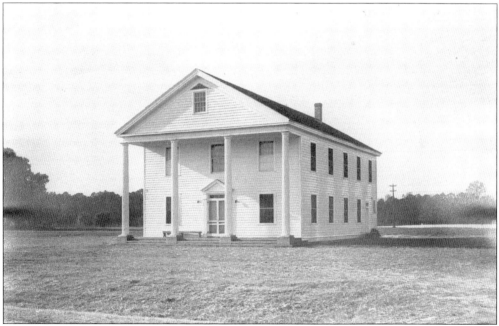

The impact of Henry Ford on Bryan Neck from 1925 to 1951 was significant to the point that Ways Station evolved from a small crossroads village into the larger community of Richmond Hill. On May 1, 1941, the name of Ways Station was formally changed to Richmond Hill, after the Fords' local residence. Pictured is the building which came to be called the "Courthouse," built by Ford in 1939 for use by the community as a place to vote and conduct civic meetings, including those of the local Masonic Lodge and Order of the Eastern Star. As far as is known, the structure was never used as a courthouse per se. The building still stands near the crossroads.

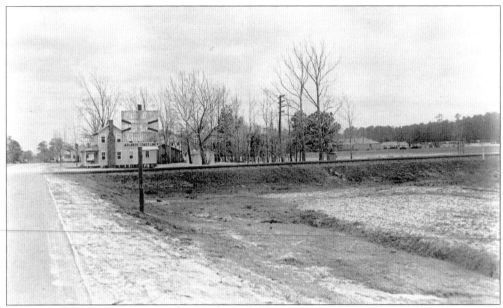

This is a scene in Ways Station c. 1938. The pavement of the Bryan Neck Road (present 144) at left ended at the Atlantic Coast Line railroad tracks. After that, it was a shell and sand road as it proceeded for about 15 miles down Bryan Neck. The house near the railroad tracks is that of the Dewey Mitchum family, which provided housing for some of the local teachers before Henry Ford had the Teacherage built. In the distance, at the right, is Ways Station High School.

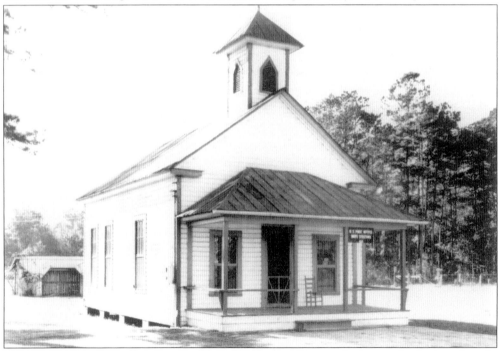

The Ways Station post office, later Richmond Hill post office, was built near the Seaboard tracks by Ford after the Butler store was dismantled to make way for the new Commissary across the Bryan Neck Road.

74

This late 1930s photograph shows vehicular traffic on the Bryan Neck Road. The view is looking east toward the railroad tracks with the high school in the distance. Sixty years later, all of the cleared area in the photograph was fully developed with stores, shops, and office complexes.

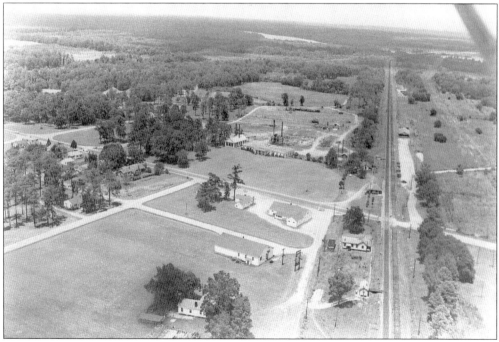

Richmond Hill is shown as it appeared from the air about 1950. In this view, north is at the top of the photograph, with the winding Ogeechee River in the distance and the Seaboard Railroad (at right) heading south to north in a perfectly straight line until curving slightly to the right in a joint crossing of the Ogeechee with the Atlantic Coast Line.

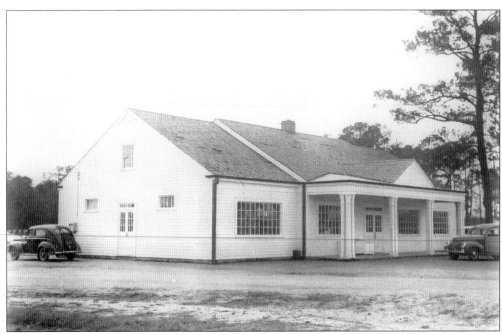

In 1941, Henry Ford built the plantation Commissary on Bryan Neck Road near the Seaboard tracks. It was an important shopping facility for both the Ford plantation employees and the Richmond Hill community at large. The Commissary sold a variety of groceries and general merchandise, including dry goods, fresh produce, and choice cuts of meats.

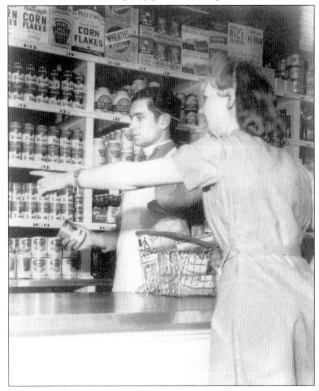

A shopper points out items for purchase at the Commissary with assistance from an unidentified clerk. Some of the managers of the Commissary during the Ford era were Carl Ramsey, Stuart Carpenter, Jim Elkin, and Dewey Mitchum.

Gordon Carpenter's store was at the small settlement of Keller, about 10 miles east of Richmond Hill on the Bryan Neck Road. Carpenter was one of those who retained his property when Henry Ford came to the area, and he continued to dispense groceries, hardware, and gasoline from his business for many years. The view above is taken from Carpenter's store showing Bryan Neck Road and a nearby residence.

The Cross Roads were and still are considered the heart of Richmond Hill. This was where U.S. Highway 17 and State Highway 63 (Bryan Neck Road, now State Highway 144) intersected. The back of the Courthouse building is seen at right in this view from the 1940s.

During the Ford era in Richmond Hill, a number of residences were built for both the workers and the managers of the plantation operations. Above is the house originally built for Stuart Carpenter and his wife, Nancy, later occupied by plantation office manager Ben Brewton and his family.

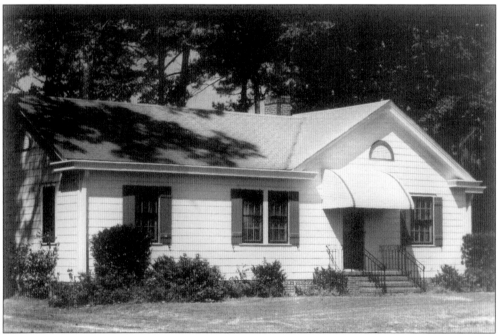

The original occupants of this house were Carl and Ruth Ramsey, the former being the manager of the Commissary. Later residents were Mr. and Mrs. Harry G. Ukkelberg. Ukkelberg was director of the research laboratory and farming activities on the Ford plantation, while his wife, Blanche, worked part time in the Ford medical clinic.

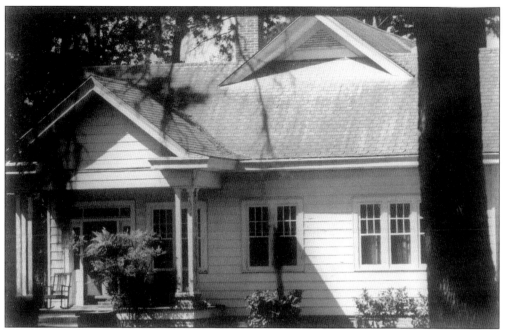

Mr. and Mrs. Dewey Mitchum resided in this house after moving from their previous residence near the high school, where they had boarded some of the teachers. Mitchum began work with the Ford plantation in 1929, serving as the labor foreman where he supervised about 75 men. Both Mr. and Mrs. Mitchum were greatly involved with the activities of the Ways Station/Richmond Hill schools, which their two children, Dale and Carolyn, attended. Dale Mitchum and his wife, Jackie, continue to reside near Richmond Hill.

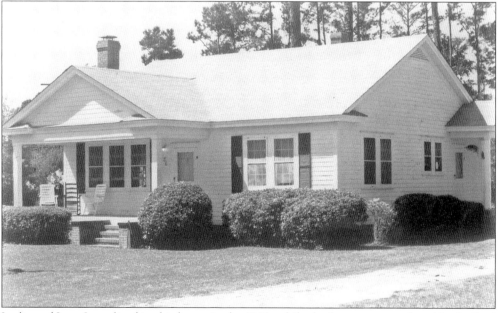

Leslie and Lucy Long lived in this house in the 1940s while the former was employed in the Ford Research Laboratory and Lucy taught math and science at Richmond Hill High School. According to the Longs' memoirs, all the Ford-built residences were painted white.

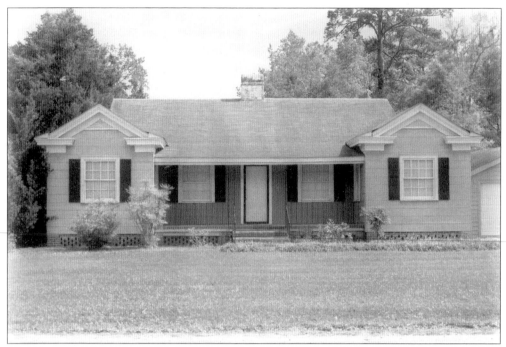

The home above was built for Dick Carpenter and his wife, Pearl. Dick was in charge of the plantation cabinet shop, and Pearl managed the lunchrooms for the Richmond Hill and G. W. Carver schools.

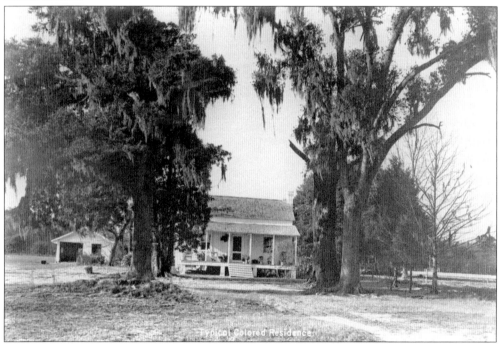

This residence was typical of the housing of many African Americans around the Richmond Hill area during the early 20th century. This particular house was owned by Lonnie Patterson, who was in charge of the blacksmith shop for the Ford plantation.

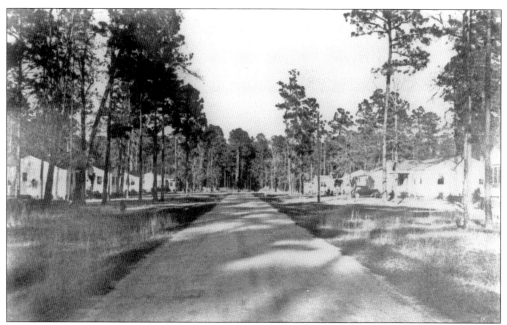

There were two housing developments built by Ford for his employees. The Bottoms Village was east of the Seaboard Railroad, while Blueberry Village was west of Highway 17 off the Clyde Road. There were about 75 two- and three-bedroom houses in the Bottoms and about 60 houses in Blueberry. No rent was charged for the occupants of these dwellings until 1945, and then only $15 per month was charged. Pictured above is a section of Blueberry.

This *c.* 1942 photograph typifies the family dwellings built in the Bottom and Blueberry housing projects in Richmond Hill.

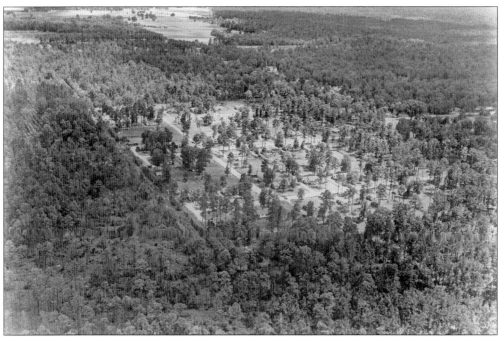

An aerial view of the Blueberry Village housing area *c.* 1950 reveals the orderly layout of homes amid tree-shaded street grids.

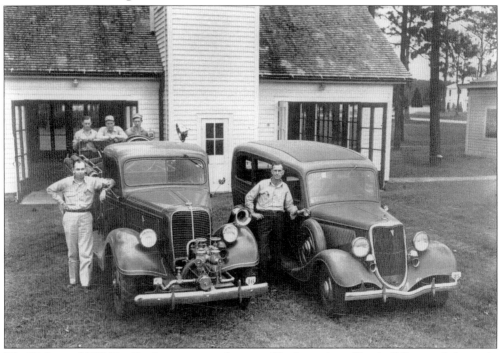

The Richmond Hill Fire Station was near the sawmill, plantation office building, and the trade school. Pictured at left is Earl Sheppard with the fire engine. At right is Herman Coffer by the ambulance. On the back of the fire truck (from left to right) are Richard Smith, Jasper Davis, and Bo Smith.

From 1901 to 1910, the Hilton-Dodge Lumber Company of Darien operated a sawmill and timber loading dock on the Belfast River about 10 miles southeast of Richmond Hill. These facilities provided employment for a number of people in the area. Some of the Hilton-Dodge sawmill employees lived in these houses near the Belfast River. Later when Henry Ford acquired the property, the houses were refurbished for Ford plantation workers and their families.

The Belfast River is pictured from the bluff c. 1935, long after the sawmill operations ended and well before the residential development that is typical of this area in the present era.

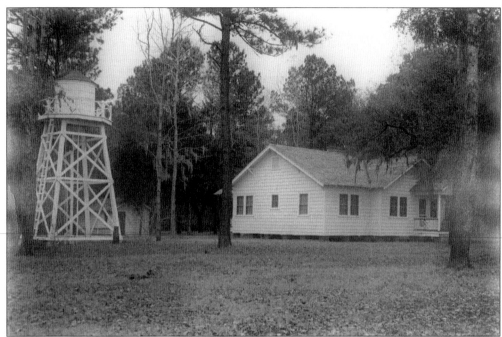

The clubhouse at Belfast was built near the river for Ford plantation employees to utilize for recreational and social outings. The structure at left is a well and water storage tank. Leslie Long, in his memoirs, noted the unusual mechanism for pumping water, which utilized neither steam power nor electricity but rather a unique "ram" device, which effectively used the pressure flow from the deep artesian well.

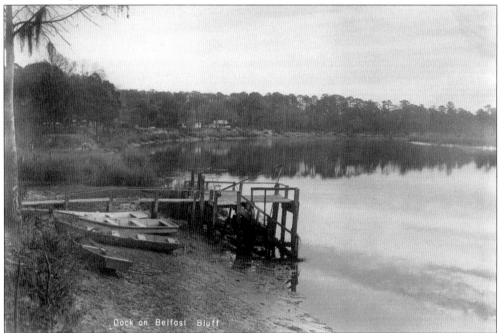

This late-1930s view of the Belfast River at low tide depicts a dock and several wooden bateaux in the foreground.

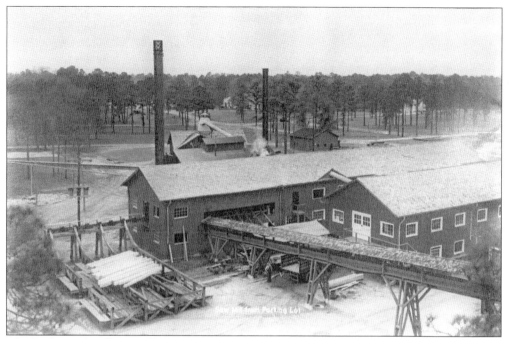

The Richmond Hill sawmill provided jobs for a large number of local citizens throughout the Ford era. Lumber produced at the mill was utilized in the construction of virtually all the Ford-era buildings in Richmond Hill.

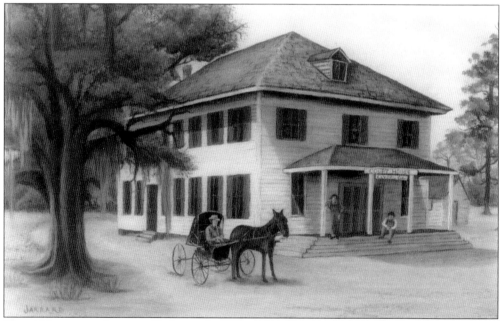

The old frame courthouse at Clyde was the seat of Bryan County government until voters opted to move the seat to Pembroke in 1935. Clyde, formerly Eden, was a tiny unincorporated community with a population of about 100 when all the buildings were torn down in 1941–1942 and the citizens relocated. This historically accurate painting was rendered by Carolyn Barber Jarrard, who used an old photograph of the courthouse.

Village of Clyde Bryan County, Ga. Property Owners 1941

1. Robert Harvey Estate
2. Ben & Lucile McCallar
3. Bryan Co. Board of Education
4. Mrs. Bertha Stewart
5. Ruby Wise Harvey, et. al.
6. Mrs. Emma Shuman
7. John L. Harvey Estate
8. J.G. Harvey
9. Mrs. E.B. Wise
10. Mrs. W.H. Davis
11. Bryan Lodge 303 F. & A. Masons
12. Mrs. Addie K. Strickland, et. al
13. Bryan Co. Board of Education
14. Bryan Co. Com. of Roads and Revenues
15. R.B. O'Brien
16. Mrs. Emma Shuman
17. Ruby Wise Harvey, et. al.
18. Clyde Methodist Church
19. Mrs. Ida Andrews
20. Mrs. W.R. Clanton
21 Ruby Wise Harvey, et. al.
22. Clyde Cemetery
23. P.R. Bacon
24. Mrs. P.R. Bacon
25. W.H. Davis
26. W.L. & Mrs. W.L. Rushing
27. Mrs. Bertha Stewart
28. Bryan Co. Com. of Roads and Revenues
29. P.R. Bacon
30. Ruby Wise Harvey, et. al.
31. American Legion Post No. 27

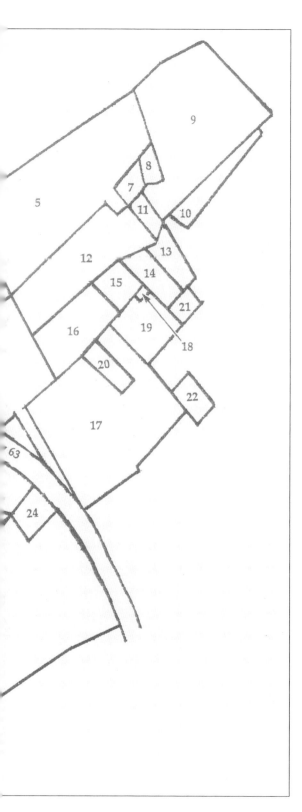

This schematic delineates the residences and public buildings of Clyde at the time the little settlement was condemned as part of the 105,000 acres of middle Bryan County confiscated by the U.S. government to make way for Camp Stewart. Many of the families—Shuman, Wise, Harvey, Davis, Bacon—had been in Bryan County for generations, some tracing their ancestry to the earliest days of the county's settlement. Many of these families tore down their dwellings and stores and rebuilt them in the environs of Pembroke to the north or in Richmond Hill, several miles to the south.

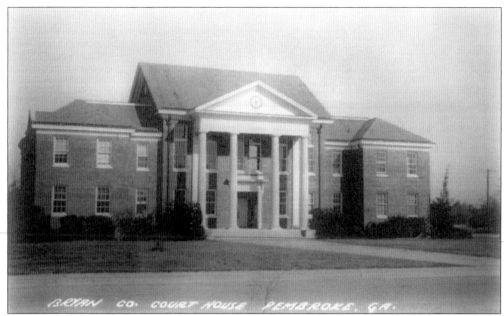

In 1935, Bryan County voters elected to relocate the seat of local government from Clyde to Pembroke, the business and railroad center of the county. Pembroke was the only incorporated town in Bryan County and was at the opposite end of the county, north of Richmond Hill. Shown above is the new courthouse in Pembroke soon after it was built in 1938.

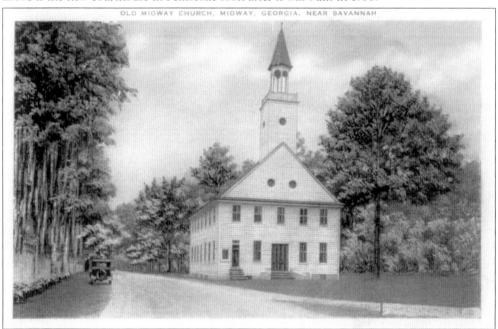

This postcard view of the 1930s depicts the old Midway Congregational Church beside the Atlantic Coastal Highway (later U.S. Highway 17). The Midway community was about 12 miles south of Richmond Hill in Liberty County. The church, still standing today and a site of great historical interest, is one of the oldest in Georgia. Puritans from Dorchester, South Carolina, began the congregation in 1752. The church shown was built in 1792.

Eight

LIFESTYLES AND LIFEWAYS

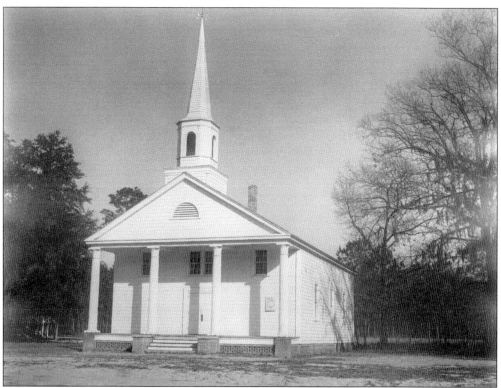

Not all life was work and labor associated with the various Henry Ford enterprises around Ways Station/Richmond Hill. Religious, social, and community life in general were key components in the energies and outlook of the citizens of Bryan Neck and lower Bryan County. Ford built churches and schools for the white and black populations of the area. Shown above is the Bryan Neck Baptist Church, refurbished by Ford. The church was built after the Civil War by the freed blacks for their services. It was on Bryan Neck Road about six miles southeast of Richmond Hill.

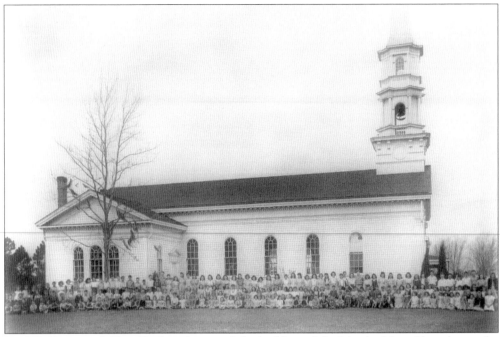

In 1937, Henry and Clara Ford implemented the building of the Martha-Mary Chapel near the Ways Station High School building and adjacent to the Community House. The name evolves from the names of Henry Ford's mother (Mary) and Clara Ford's (Martha). The students of the nearby school utilized the facility as a chapel in which devotionals were conducted by the students under the supervision of their teachers, according to Leslie and Lucy Long. The chapel is today owned by St. Anne's Catholic Church.

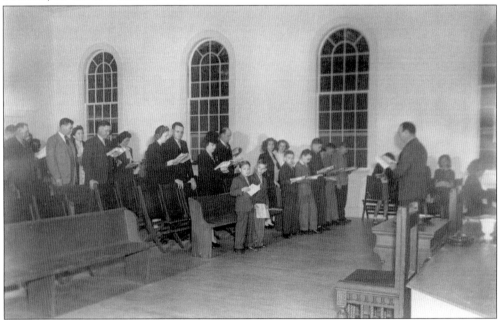

Community church services are shown above being conducted in the sanctuary of Martha-Mary Chapel c. 1940.

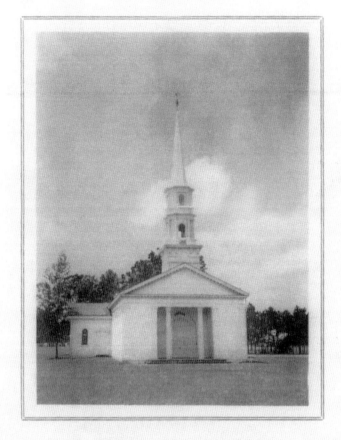

RICHMOND HILL, GEORGIA

APRIL 26, 1942

The image depicts the front of a typical Sunday service church program for Martha-Mary Chapel, in this instance Sunday, April 26, 1942. Inside the program, the order of service includes a scripture reading by Leslie Long, a duet by Betty Jean Thomas and Carolyn Mitchum, and a reading by Lucy Bunce. Hymns sung that day included "When the Roll is Called Up Yonder," "Yield Not to Temptation," "Love Divine," and "O Jesus, I Have Promised."

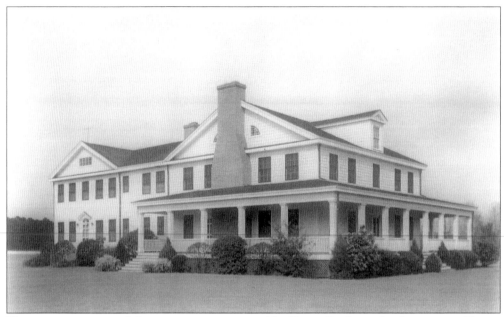

The most prominent of the structures constructed by Henry Ford was the Community House, above, completed in 1936 on a tract near the high school and on a plot that a year later included the Martha-Mary Chapel. The Community House was built by the Fords to enhance the educational, social, and cultural development of the people of the community, particularly young people. Home economics, cooking, sewing, and all the social graces and courtesies were taught at the Community House at no cost to students and parents.

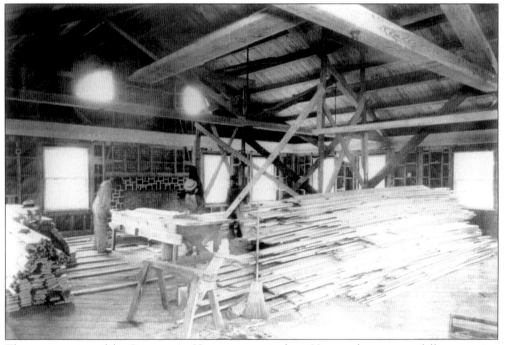

The construction of the Community House was meticulous. Here workers are carefully measuring and sawing boards used for the walls on the second floor.

In this *c.* 1940 image, Vardelle Lowery, Elizabeth Lanier, and Georgia Harvey (all wearing the popular saddle oxford shoes) are learning the rudiments of cookery. The kitchen of the Community House was equipped with the latest innovations in appliances, including ovens, stoves, and refrigerators.

Amber Lee came to Richmond Hill in 1943 to serve as hostess and director of the Community House. She served in this capacity until 1951, when the Community House activities were suspended following the death of Clara Ford.

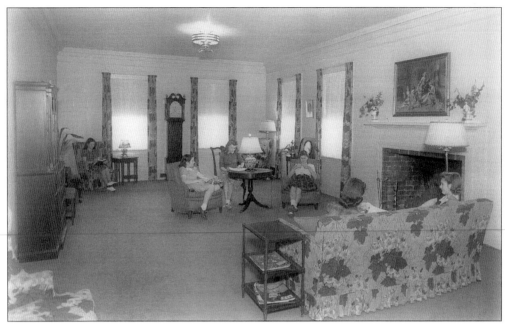

Home economics was an important course of study for high-school-age students in Ways Station/ Richmond Hill. In this 1940 photograph, several girls—(from left to right) unidentified, Doris Burch, LaWanda McCallar, Betty Lou McAllister, Gladys Smith, and Elizabeth Lanier—are relaxing in the large living room of the Community House.

The Community House had a number of smaller rooms that were utilized for specialized instruction. Here (from left to right) Elizabeth Akins (instructor), LaWanda McCallar, Martha Burch, Georgia Harvey, and Gladys Smith are engaged in a sewing class.

Henry Ford provided an orchestra to play for young people and adults taking dancing instruction at the Community House. The orchestra members often came down from Michigan with the Fords.

Dancing instruction was one of the most popular of the many social activities occurring at the Community House, as evidenced in this image of students learning the quadrille dances in the ballroom. Ford hired Ebba Thomson, wife of plantation office manager Robbie Thomson, to teach dancing, including square dancing and ballet, at Richmond Hill. Often Mr. and Mrs. Ford appeared at the Community House to enjoy the activities of the students.

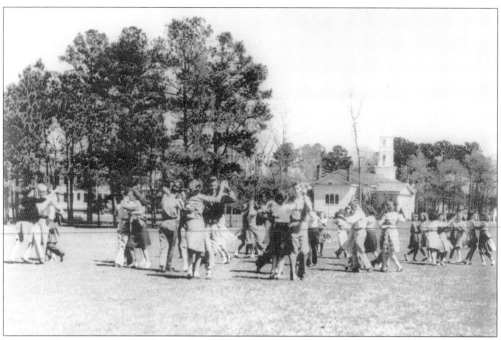

These students are enjoying the good weather to practice their dancing routines outdoors. In the background are the Community House (left, through the trees) and the Martha-Mary Chapel.

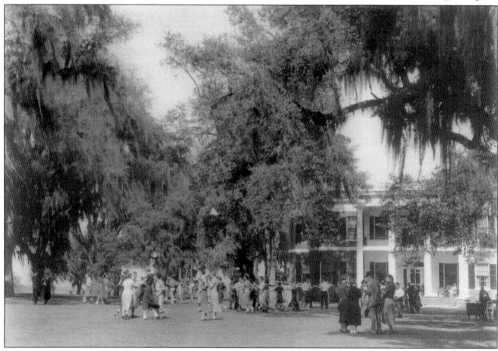

On several occasions, the Fords invited the students and instructors of the Community House dancing classes to their residence at Richmond to try their skills on the front lawn of the mansion with the Fords' orchestra providing the music. In this 1941 scene, the various quadrilles are performing. Mr. and Mrs. Ford are in the quadrille in the right foreground.

Nine

SCHOOLS AND EDUCATION

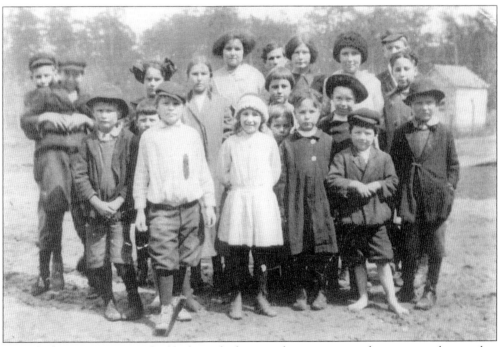

Formal education, separate for blacks and whites at the time, was rudimentary and somewhat haphazard in the early 20th century. There were several small schools in the Ways Station area. The undated *c.* 1900 image above depicts young students from one of the local one-room schools. There were small schools for whites at Clyde and Ways Station and one-room schools for blacks at Cherry Hill, Oak Level, and Daniel Siding. With the arrival of Henry Ford in 1925, the local education picture began to brighten.

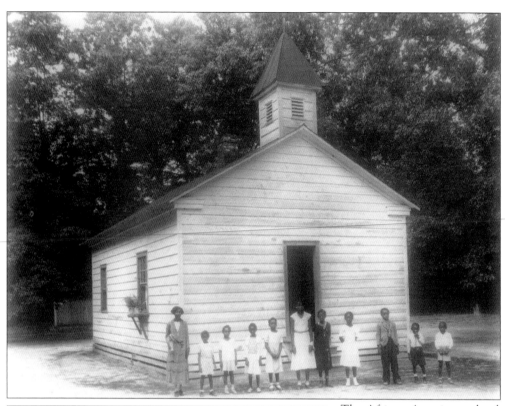

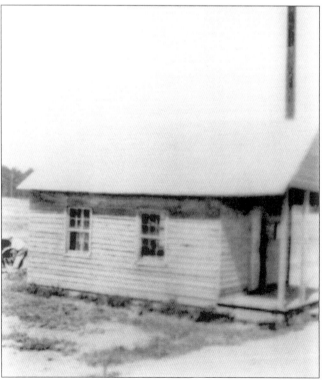

The African American school at Cherry Hill, shown about 1934, featured a whitewashed exterior and was typical of the one-room structures for poor whites and blacks during the Depression era. Ford implemented repairs and upgrades to the one-room school buildings for blacks before supporting the construction of the consolidated George Washington Carver School for blacks in the late 1930s.

The structure shown served as the one-room school for whites in Ways Station for a number of years in the early 20th century. Students attended this school only through the sixth grade, until the Consolidated School for whites was opened in 1928.

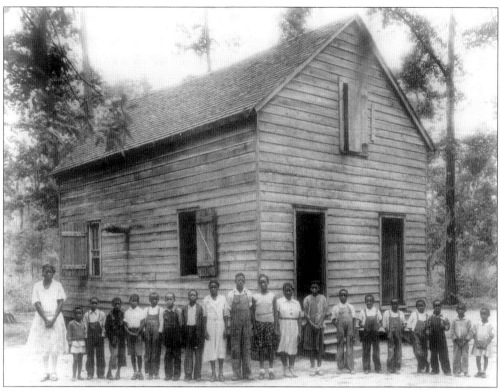

The building above is the one-room school for blacks at Oak Level at the lower end of Bryan Neck, about nine miles east of Ways Station. This image was taken in 1934 and shows the teacher at left and her students of varying ages.

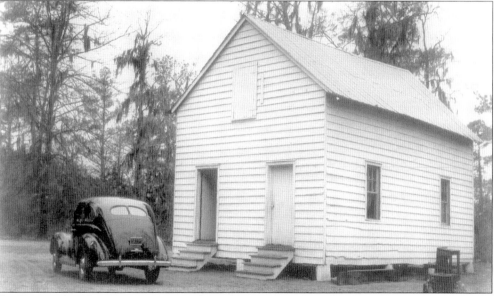

Ford assisted with improvements to the African American schools in lower Bryan County. Compare this 1938 image of the Oak Level school with the picture of the same building in the photograph above, taken four years earlier.

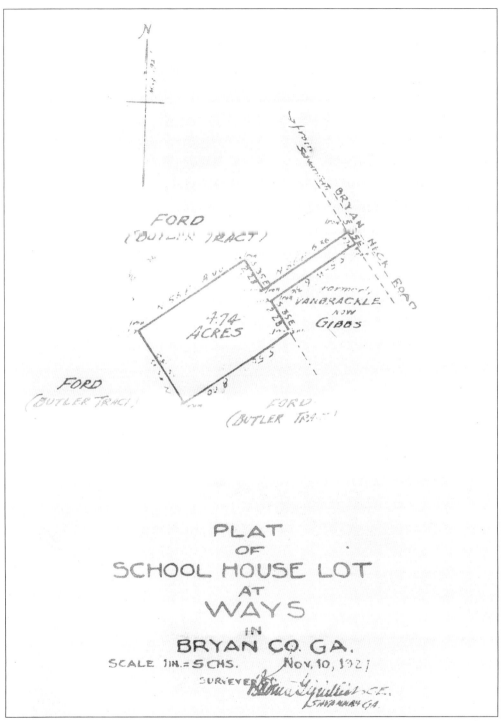

PLAT
OF
SCHOOL HOUSE LOT
AT
WAYS
IN
BRYAN CO. GA.
SCALE 1IN.=5CHS. Nov. 10, 1927
SURVEYED

The 1927 survey delineates plans by the Bryan County Board of Education for the new consolidated school at Ways Station. The "School House Lot" was situated just off Bryan Neck Road in Ways. Work on the brick school, typical of Georgia school buildings of the era, was largely completed by the end of 1928.

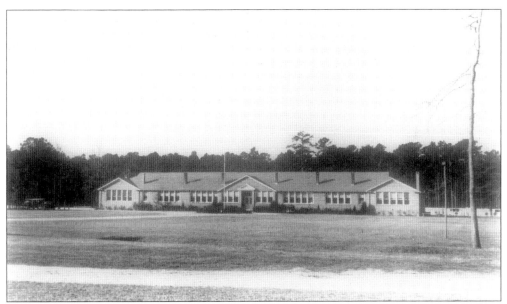

The Ways Station Consolidated School housed all local students through the 11th grade when it was opened in 1928. School buses brought in the students from other sections of Bryan Neck. This image was made in 1939 after Henry Ford implemented the addition of four rooms on to the building to house chemistry and physics labs. The Consolidated School was administered by the Bryan County Board of Education with the assistance of Ford, who financed expenses for maintenance, buses and drivers, teacher salary supplements, and free lunches for teachers and students.

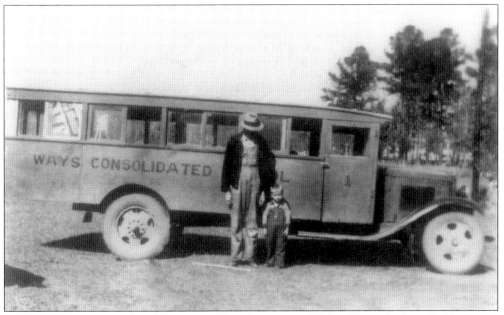

School buses transported students to the Ways Consolidated School from the lower half of Bryan County, including the communities of Keller (southeast of Ways), the county seat at Clyde (northwest of Ways), and areas south of town along the Atlantic Coastal Highway. The bus driver and child are unidentified in this image made c. 1928.

School athletics at the Consolidated School were an integral part of the curriculum. This image of the girls' high school basketball team was likely made in the mid-1930s. The only identifiable players are Virgie Barber (far left), May Vincent (far right), and Maude Moore (third from right).

The 1937 graduating class of Ways Station High School was small but enthusiastic. According to Leslie Long in his memoirs, Henry Ford paid for the senior classes to make the trip to Dearborn each year from 1937 until 1942. The class above is pictured in front of the Martha-Mary Chapel at Dearborn in Greenfield Village.

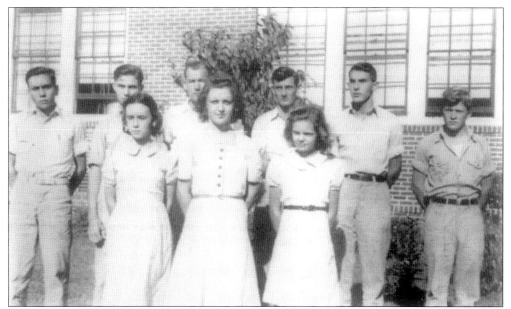

The Ways High School Student Council for the 1938–1939 school year included, from left to right, (first row) June Davis, Brunelle Smith, and Peggy Speir; (second row) Cecil Rahn, Eldred Hodges, W. J. Logan, Fillmore Gill, Bill Eidson, and William Gregory.

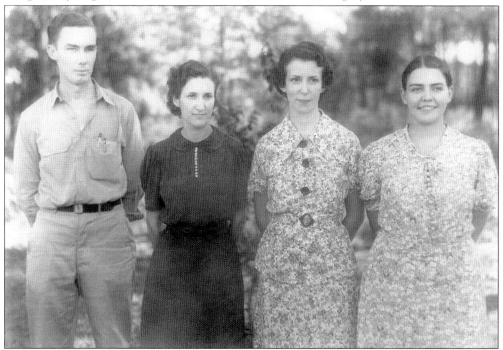

Four of the teachers at the Ways High School were, from left to right, Fulton Bell, instructor and head of the industrial arts department; Vivian Williams, home economics; and Rachel Partain and Mary McLeod. The Ways Consolidated School attracted outstanding teachers in all fields of study. They received state and county school board salaries in addition to supplements provided by Henry Ford.

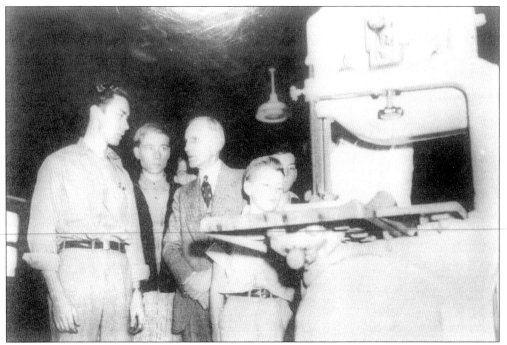

Shop classes were an important component of the industrial arts curriculum of the local high school. Here Henry Ford chats with shop teacher Fulton Bell (left) and students Kermit Davis, S. A. Blount, Henry Speir Jr., and Redmond Gill.

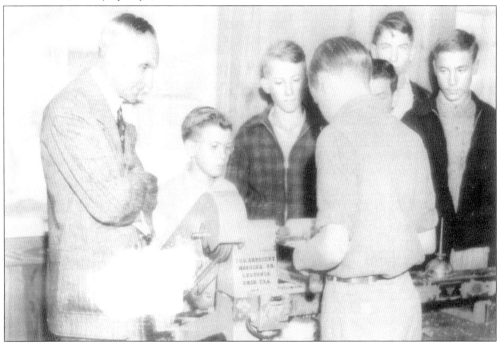

Henry Ford was genuinely interested in what the students were learning, as seen in his observation of students at work on a metal working machine in the shop class. Shown from left to right are Ford, Henry Speir Jr., Gordon Blount, Richard Smith, Redmond Gill, S. A. Blount, and Kermit Davis.

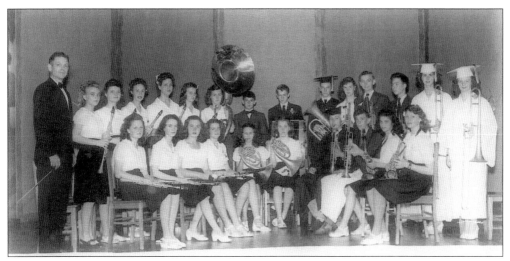

When Ways Station became Richmond Hill in 1941, the high school was renamed Richmond Hill High School. The school band is shown on graduation night in 1946. From left to right are (seated) Mary Gill, Cecelia Harvey, Beth Ann Sharpe, Evangeline Maples, Doris Dukes, Lois Williams, Allen Womble, Dale Mitchum, Jackie Simmons, and Betty Darieng; (standing) band instructor William Deal, Margaret Glynn, Jeanne Hipp, Winnie Mae Eason, Betty Zettles, Nan McCallar, Bertie Lee Carpenter, Woody Judy, Johnny Dukes, Lawrence Davis, Helen McAllister, Ira Womble, Fulton Mehaffey, Evelyn Carpenter, and Jerry Hipp. Henry Ford paid for the band's instruments when the band was begun in 1940.

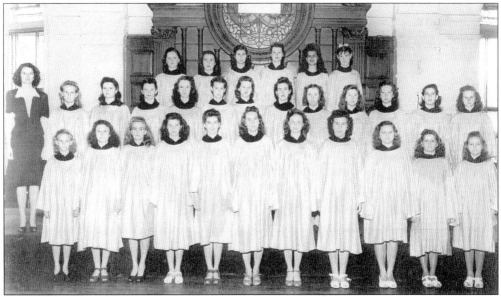

Richmond Hill High had a girls' glee club in the mid-1940s. Pictured from left to right are (first row) Betty Findley, Evelyn Smith, Margaret Glynn, Jackie Simmons, Evelyn Strickland, Kitty Cheeves, Winnie Mae Eason, Wilma Harden, Reba Davis, Juanita Shuman, and Lillie Davis; (second row) teacher and coach Anne Wilson, Wilda Findley, Jeanne Hipp, Jerry Hipp, Cecelia Harvey, Nan McCallar, Freida Speir, Mildred Smith, Lois Williams, Margaret Clark, Louise Moore, Lula Phillips, and Gertrude Davis; (third row) Mary Gill, Beth Ann Sharpe, Evelyn Carpenter, Betty Darieng, Betty Jean Thomas, and Helen McAllister.

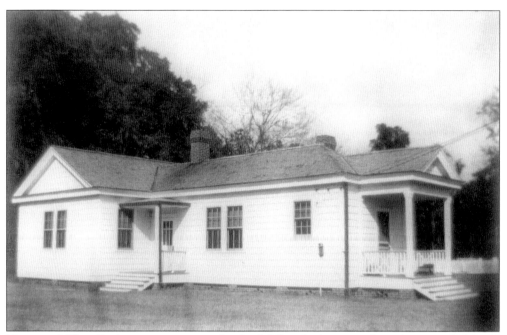

Henry and Clara Ford were proponents of early childhood education; thus, they provided funds for the construction and staffing of two kindergarten facilities. Pictured above is the kindergarten building at the Keller community, built in 1937.

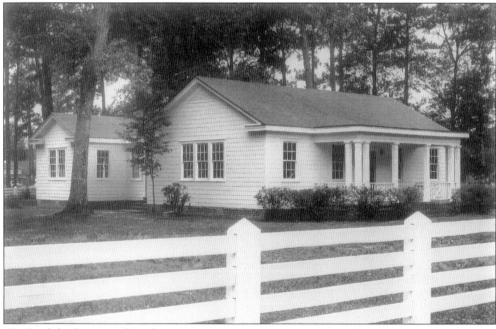

The Fords built a second kindergarten in 1940–1941 at Richmond Hill with the layout including two large classrooms, a kitchen, and a bathroom. This building, now owned by the nearby Magnolia Manor Methodist retirement home, serves as the Richmond Hill Museum. It is also, courtesy of Magnolia Manor, the home of the Richmond Hill Historical Society. Remaining in the building are the small, wooden lockers that lined the walls for the children's belongings.

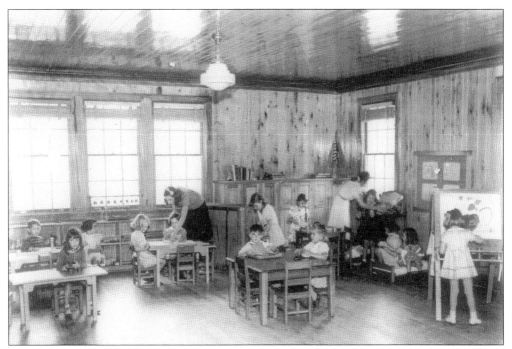

The Richmond Hill kindergarten, the interior of which is shown above c. 1945, accommodated children aged three to six. The kindergarten director was Margaret Mustin, whose undergraduate degree was from Shorter College in Rome, Georgia, and advanced education degrees were from Columbia University in New York. Mrs. Willie Newton Bennett became head of the kindergarten in 1945, with assistance from Annie Ridgell and Evelyn Phillips.

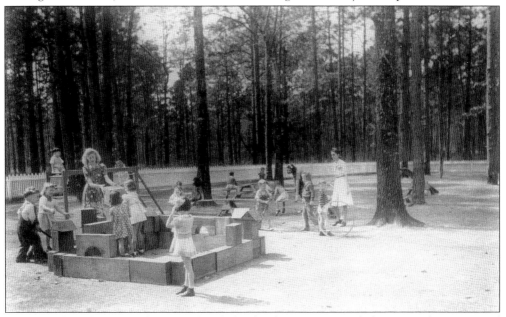

Playground facilities on the grounds of the kindergarten provided organized recreational outlets for the children. The equipment and structures were built by the Ford plantation workshops nearby.

The 1940s and early 1950s were the high points of the Henry Ford–supported educational refinements in the Richmond Hill area. Here Anne Baylor enjoys some quality time with one of her furry friends.

This image of an unidentified young lad of the 1940s era at Richmond Hill clearly demonstrates the ever-increasing interest among American children for the Western cowboy. The photograph demonstrates that this culture had made its way to rural, coastal Georgia. The Cherry Hill house is seen in the background of this photograph.

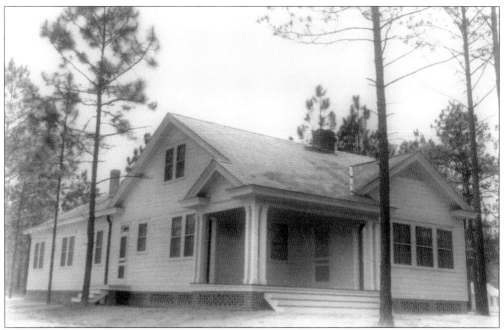

Henry Ford built the Teacherage to house unmarried Ways School teachers. Most of the married teachers had their own residences or lived in Ford-built houses in the community. The Teacherage, shown here in 1940, was a block from the school and teachers could room there for the nominal rent of $36 per month, including three meals per day.

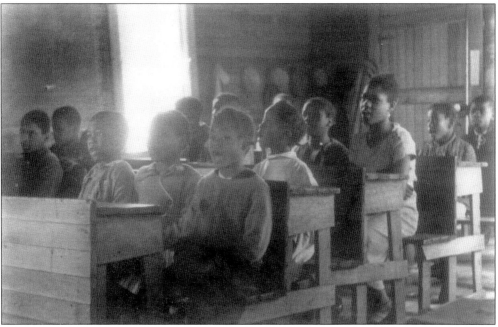

Despite the improvements of facilities implemented by Henry Ford before the building of the new George Washington Carver School, educational facilities for local African Americans were small and crowded, as evidenced by this view of students in the one-room school building at Cherry Hill c. 1935.

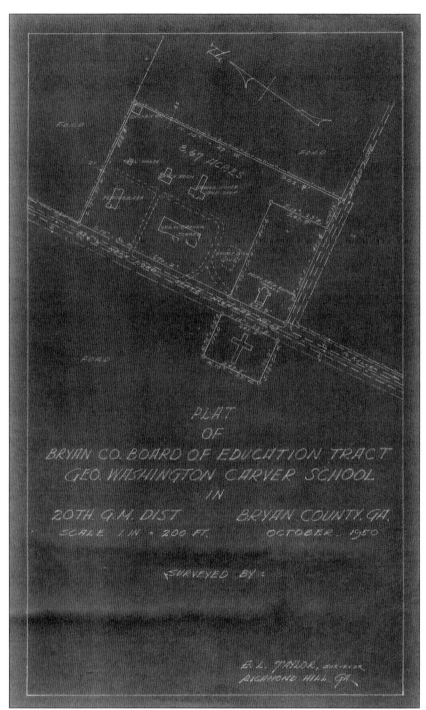

In 1939, Henry Ford underwrote the construction of the new George Washington Carver School for the black students of lower Bryan County. The school was about six miles east of Ways Station on Bryan Neck Road adjacent to the African American Bryan Neck Baptist Church. Ford also built a teacherage, lunchroom, and industrial arts shop on the premises, all shown in the survey plat above dated October 1950.

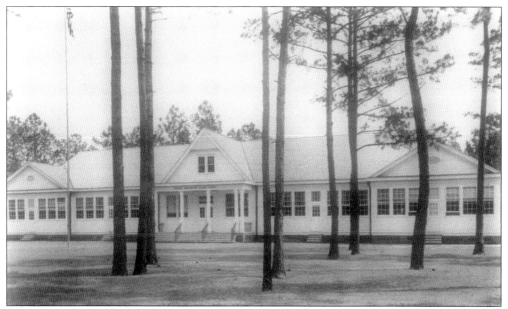

The first principal of the Carver School was Prof. Herman G. Cooper. According to Leslie Long, tests were conducted to determine the educational level of the students, the results of which established the sixth grade as the highest grade level when the school opened in 1939. As students advanced, a higher grade was added each year until there were 11 grades, which conformed with the rest of the Georgia state school system at that time.

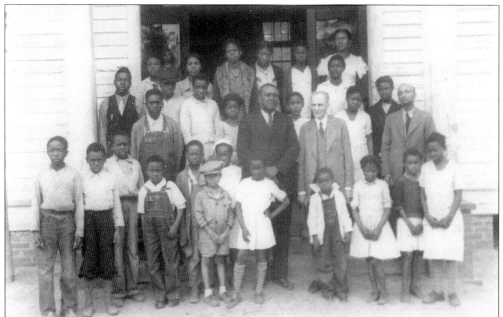

Ford is shown posing with Rev. Willie C. Shipman (standing left of Ford) and students at the Daniel Siding School. Identifiable students include Walter Cuthbert, Matthew Green, Elving Jones, Ellena Colman, Katherine King, Benjamin Miller, Marvin Mullins, Aletha Bizzard, Pauline Davis, Ronnie Lee, Lora Jackson, Mr. Hill, Henry Mullins, Essie Lee, James Bizzard, Thelma Mullins, and Eletha Shipman.

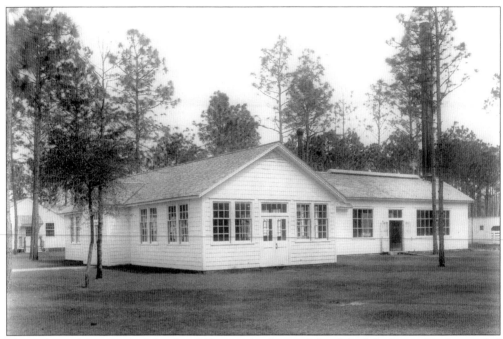

The Industrial Arts Trade School and Shop at the Carver School, built by Henry Ford, provided classes in such trade skills as metalworking and woodworking.

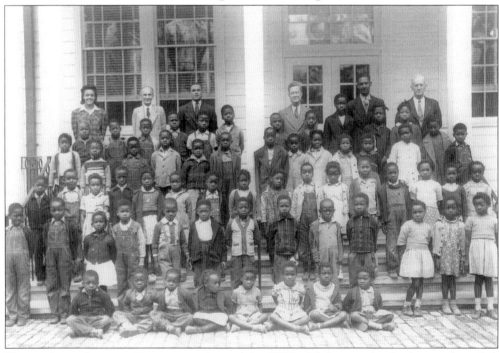

First-grade students at Carver are pictured in 1940. Adults on the back row from left to right are A. V. Haven, teacher; Henry Ford; H. G. Cooper, principal; Frank Campsall, Ford secretary; C. W. Savage, trade school instructor; and J. F. Gregory, Richmond Hill plantation superintendent.

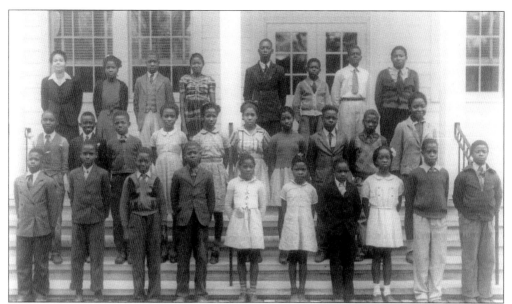

Fourth- and fifth-grade students at Carver School are shown in 1940. Pictured from left to right are (first row) Charles Adams, Daniel Giles, Dan Brown, Abraham Blige, Margaret Alexander, Essie Morrison, Rudolph Harris, Susie Mae Mitchell, William Blige, and Rufus Giles; (second row), Thomas Burke, Bennie Campbell, Benjamin Boles, Lena White, Nancy Morrison, Alice Bess, Elise Koger, Clifton Thomas, Thomas Green, and Lucille Blige; (third row) teacher Sadye Westbrooks, Gladys Blake, Horace Blige, Hattie Mae Jemison, Thomas Louis Jenkins, James Houston, Charles Boles Jr., and Ernest Loadholt.

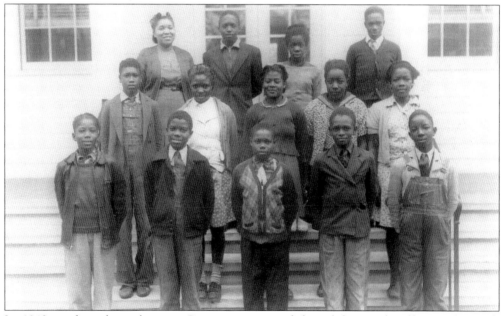

In 1940, sixth-grade students at Carver are pictured from left to right: (first row) Joseph Campbell, Charles Hargrove, Herman Green, Charles Bizzard, and Harry Green; (second row), Charles Lee White, Florence Barnard, Martha Blige, Ernestine Young, and Lillian Mitchell; (third row) teacher Mrs. Rosemond, Richard Brown, Carrie Young, and Robert Green.

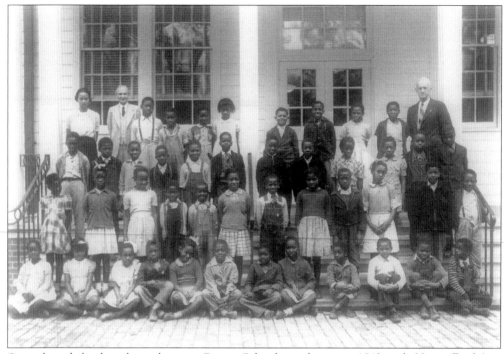

Second- and third-grade students at Carver School are shown in 1942 with Henry Ford (top left) and Jack Gregory (top right).

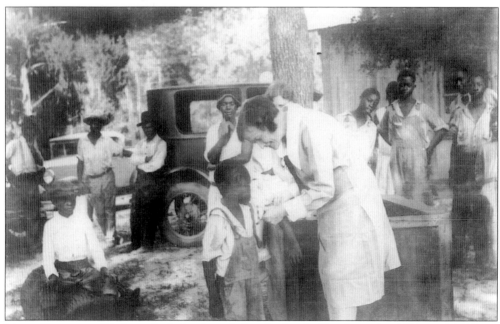

Nurse Constance Clark worked closely with local school officials in the 1930s and 1940s to ensure that all students, black and white, received proper medical care and immunizations.

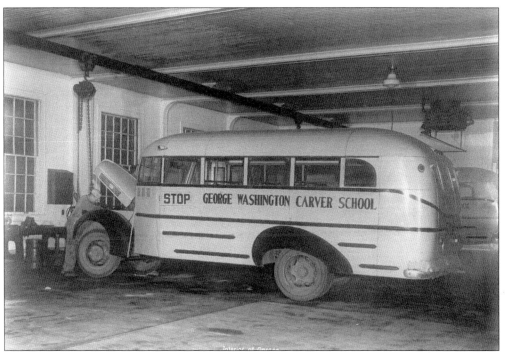

Henry Ford provided a modern school bus to transport students to and from the Carver School each day. Here the Carver school bus receives maintenance at the Ford garage and shop.

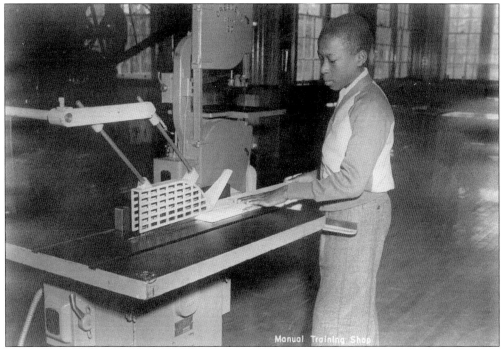

The Industrial Arts Trade School was an important part of the G. W. Carver School campus. Boys received 90 minutes of shop training three days each week. In the photograph above, Albert Brown is learning skills on a table saw.

Three unidentified, although clearly somewhat shy, Carver School students are shown posing for the photographer on the playground during recess activities.

Geo. Washington Carver School

Ford provided modern facilities for the education of students at the Carver School, as seen in the photograph of classroom activities above. Classrooms were well lit (windows at left), and each student had their own desk.

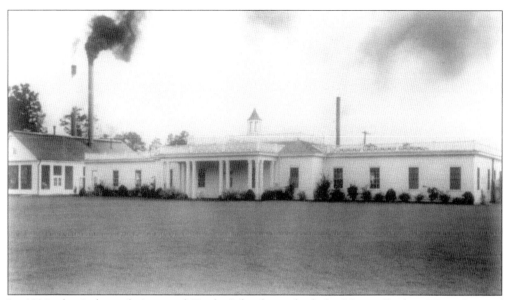

In 1938, the Industrial Arts and Trade School was built by Henry Ford at Ways Station/ Richmond Hill. This facility was largely for the use of the high school students. The trade school was built on Bryan Neck Road within easy walking distance of the high school. Leslie Long notes that students in the 9th grade were required to take shop classes, while the classes were electives in the 10th and 11th grades. Classes were also available for adults in the evenings at the trade school.

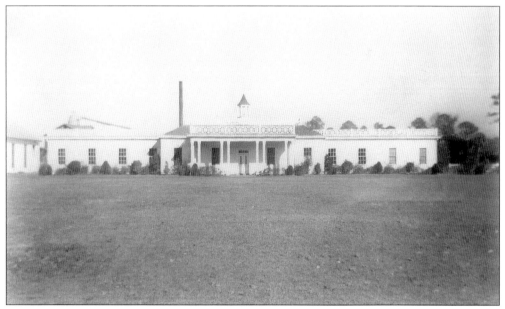

Another view of the trade school from 1944 depicts a more sedate appearance than the activity so apparent in the image above. This may be attributable to the World War II national emergency which necessitated rationing of many domestic commodities and required the service of so many young men, including teachers and instructors, for military duty.

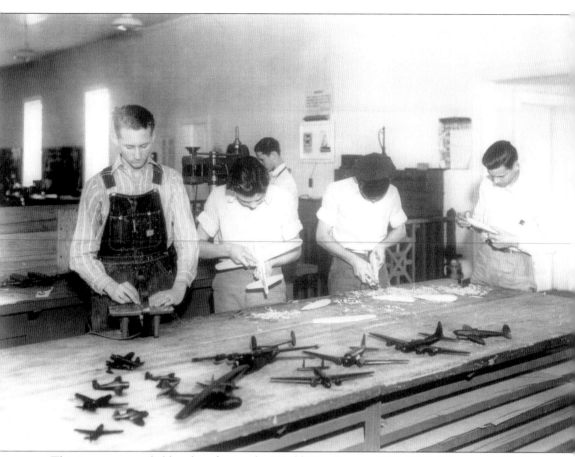

This image was probably taken during the World War II years, 1941–1945. Richmond Hill High School students are building model fighting aircraft during shop class.

Ten

END OF AN ERA

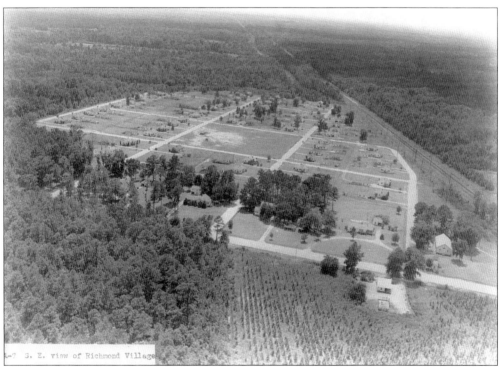

R-7 S. E. view of Richmond Village

Henry Ford died in 1947, followed by the death of Clara Ford in 1950. After that, the Ford estate in Dearborn disposed by sale of all the Ford properties in Richmond Hill and lower Bryan County to International Paper Company (IP) for about $5.5 million. IP was chiefly interested in acquiring the lands for timber harvesting. Surveys were made of all properties, including the aerial image above of some of the residential tracts. International Paper later sold all of the buildings associated with Ford, including the mansion, Community House, and Martha-Mary Chapel. The Ford mansion and 1,800 acres of lands on which it sits (including the Cherry Hill and Richmond tracts) have changed hands a number of times over the years.

Estate of Henry Ford
Dearborn, Mich.

May
25th
1951

Douglas, McWhorter & Adams
15 Drayton Street
Savannah Georgia

Attention: Mr Edwin A McWhorter

Dear Mr McWhorter:

As suggested in your communication of April
24th, we have had the bill of sale whereby The Ford
Foundation conveys the two school bus chassis to Bryan
County Board of Education executed, and the State of
Georgia 1951 Certificates of Registration assigned by
The Ford Foundation to Bryan County Board of Education.

We are enclosing herewith, the original docu-
ments for your presentation to the School Board, and a
photostatic copy of each to be retained in your files.

Very truly yours

L J THOMPSON

Estate of HENRY FORD

LJT/h

enc

c.c. with photostatic copies of documents to:
 Mr Henry I Armstrong Jr
 Mr B J Craig
 Mr Ray Newman

This letter dated May 25, 1951, is reflective of the voluminous amount of correspondence and documentation associated with the closing of the various activities and operations of Ford's Richmond Hill plantation. The Ford Archives at Dearborn is the repository for all the records and correspondence relating to the 26 years of the Ford family's activities in Richmond Hill.

During the 1940s and 1950s, Richmond Hill began to realize a thriving tourist trade for the first time. This 1937 image of the Royal Park Court on U.S. Highway 17 was representative of one of the first area businesses to cater to the traveling public.

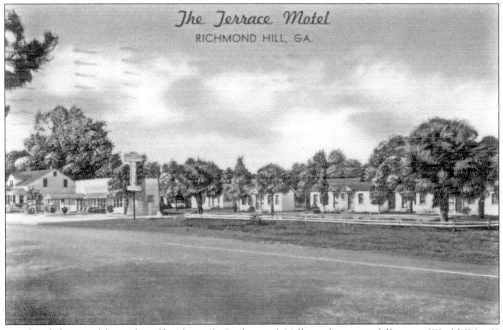

Much of the southbound traffic through Richmond Hill in the years following World War II was on its way to Florida, an increasingly popular vacation destination. Tourist courts along the Georgia coast prospered as travelers frequented the conveniently located facilities on the primary highway conveyor, U.S. Highway 17. The Terrace Motel in Richmond Hill is shown above.

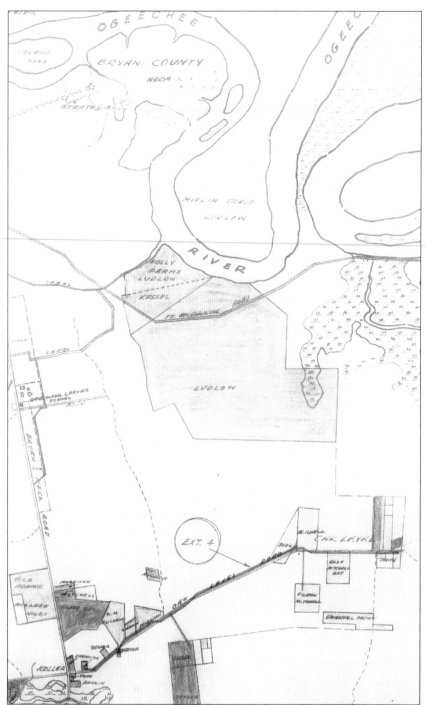

The sale of the Ford lands on Bryan Neck necessitated the complete resurvey of all properties as part of the transfer process. The Bryan County deed and plat records contain the records of these surveys and property descriptions. Copies of many of the documents are contained in the archives of the Richmond Hill Historical Society. The survey above delineates lands flanked by the Ogeechee River, Oak Level Road, and Bryan Neck Road, including the Carver School.

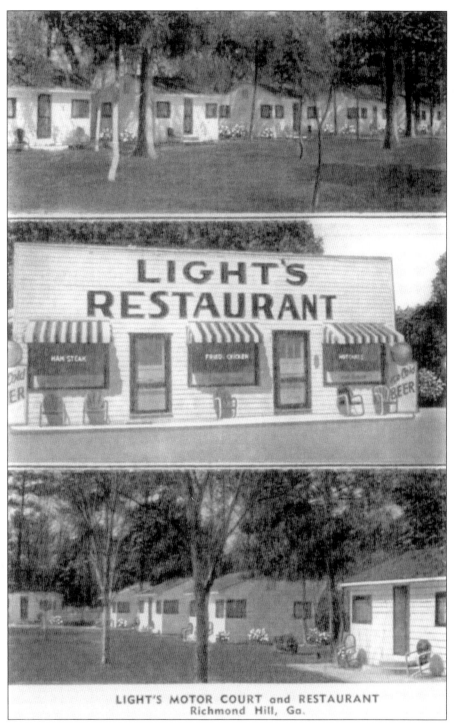

LIGHT'S MOTOR COURT and RESTAURANT
Richmond Hill, Ga.

Light's Motor Court and Restaurant in Richmond Hill catered to north-south traffic between Florida and the North during the 1950s. Even though Richmond Hill remained a small, sleepy, coastal Georgia community during this period, the U.S. Highway 17 traffic through town was almost constant in the era prior to the construction of Interstate 95.

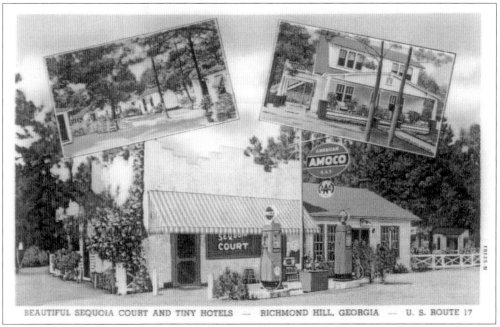

BEAUTIFUL SEQUOIA COURT AND TINY HOTELS — RICHMOND HILL, GEORGIA — U. S. ROUTE 17

Some of the buildings of the old Sequoia Court in Richmond Hill are still standing. This postcard view from the mid-1950s depicts this local enterprise in its prime. When Interstate 95 was built through the area in the early 1970s, most of the tourism-oriented motels and restaurants along U.S. Highway 17 fell on hard times due to the significant decrease in business.

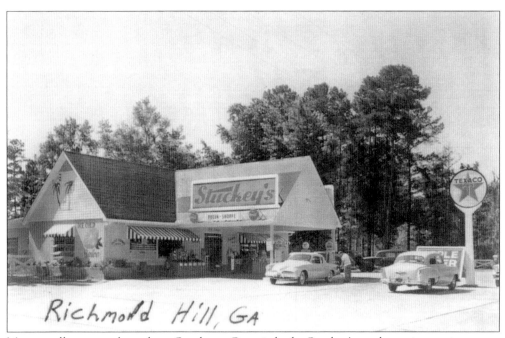

Many smaller towns throughout Southeast Georgia had a Stuckey's on the major tourist routes, and Richmond Hill in the 1950s was no exception. Stuckey's was a Georgia-based corporation featuring such signature products as pecan divinity and salt-water taffy.

210-ACRE INDUSTRIAL TRACT
Excellently Priced, Strategically Located

With Frontage on Ogeechee River and Access to Intracoastal Waterway; Bounded by Main Lines of 2 Railroads; Unlimited Supply of Mill-Process Water; Plus INDUSTRIAL, OFFICE, FIRE STATION, AND STORAGE BUILDINGS

RICHMOND HILL, BRYON COUNTY, GEORGIA No. 80340

This 210-acre industrial site in Richmond Hill, only 18 miles from Savannah by excellent highways, is an attractively priced purchase especially suitable for any plant requiring railroad frontage, easy access to good roads for trucking, and river frontage for barges. There is an unlimited water supply from deep wells or it may be piped from the Ogeechee River which connects with the Intracoastal Waterway and the Atlantic Ocean. Present taxes are low, and the authorities offer the purchaser every assurance that improvements and developments will be assessed with every consideration.

Of the 4 buildings on the site (extensively developed by Henry Ford in the 1930's), the major industrial structure is in sound physical condition and contains 16,265 sq. ft. of floor space. Facilities include plumbing, coal-fired heat, electricity, and a 200'-long monorail system with hoist. A 35'x93' storage building adjoins. There is also a 25'x53' office building now in use. It is in excellent repair and contains a lobby, 5 offices, 2 rest rooms, and a full-size built-in safe. The 30'x39' fire station has a concrete floor, 3 garage doors, pine-paneled walls and ceiling. It is easily adaptable for use as a garage, additional office building, or caretaker's cottage.

The site is advantageously situated on State Route #63, ½ mile from U. S. #17, the main coastal highway between New York and Miami. The Savannah Airport, with two major airlines, is only 20 miles away.

The property adjoins "Richmond Hill Plantation" a cattle farm and waterfront estate of over 1000 acres, with a beautiful 10-room residence and extensive improvements. Developed by Mr. Ford in the '30's, it is also offered for sale (Ask for Brochure 80337).

PROPERTY: Approx. 210 Acres. 2372' road frontage. 2700' water-frontage on Ogeechee River. 93.5 acres high ground (73.5 acres cleared, 20 acres woodland). 116.5 acres unreclaimed rice fields. Bounded by main lines of 2 railroads (The Seaboard and Atlantic Coast Line). Ogeechee River gives access to Intracoastal Waterway, Ossabaw Sound, and Atlantic Ocean. (River barges of adjoining in-

dustrial plant use this waterway). Water obtainable from 3 sources. Richmond Hill pumping station with 2 deep wells; unlimited supply of mill-process water from river; 4 deep wells on property. Taxes: Low assessment, with every consideration to be extended by the County because of community interest in improvement and development of property. Adjoining "Richmond Hill Plantation", also offered for sale, comprised of over 1000 acres, with superb residence built by Henry Ford, producing acreage, excellent equipment, etc. (Ask for Brochure 80337).

IMPROVEMENTS: *Building #1, Industrial.* 1-story, H-shaped; frame construction; built 1933. 16,265 sq. ft. floor space. Wood shingle roof; 16' ceiling clearance. Concrete floor. Facilities include: plumbing, electricity, coal-fired boiler with 3 unit heaters, monorail system approx. 200' long with hand-operated hoist. Good general-purpose structure in sound condition, suitable for industrial, garage, warehouse use. *Building #2, Office.* 1-story, frame construction; built 1938. 25'x53' overall. Plumbing, heating, electrical systems; full-size built-in safe. Pine-paneled wainscoting, plaster walls and ceilings. 5 office rooms, 2 rest rooms, lobby. Building in excellent repair and now in use. *Building #3, Fire Station.* 1½-story, frame construction; built 1938. 30'x39' overall. Concrete floor, pine-paneled walls and ceiling. 3 garage doors. Can accommodate 3 trucks or fire-fighting equipment. Stairs and brass pole connect stories. Firemen's quarters on 2nd floor. Building is in good repair and suitable for garage, additional offices, caretaker's cottage. Included in purchase: '38 Ford fire truck and equipment. *Building #4, Storage Shed,* partially open. Frame construction, metal roof. 35'x93' overall.

LOCATION: Richmond Hill, Bryan County, Georgia. On Ogeechee River with access to Intracoastal Waterway and Atlantic Ocean. On State Route #63, ½ mile from U. S. Route #17, main coastal highway between New York and Miami. Bounded by 2 main line railroads. Savannah Airport with 2 major airlines, 20 miles. ½ mile from general store, schools, churches. All urban facilities in Savannah, 18 miles.

OFFERED AT $95,000

OWNER: Monadnock Paper Mills, Inc., Mr. Gilbert Verney, Pres., Bennington, New Hampshire. Tel.: ANtrim 99.

PROPERTY: Richmond Hill, Bryan County, Ga.

INSPECTION: Through: Mr. Marvin I. Sharpe, Manager, on property. Tel.: Richmond Hill 2521.

Brokers: If you wish active help of local broker (not obligatory) on a co-brokerage basis, use:

MR. T. RANDOLPH COOPER
R. L. & T. R. COOPER
P. O. Box 1153, Morel Bldg.
5 Bull Street, Savannah, Ga.
Tel.: ADams 3-1271

Owner authorizes one commission of 5% of the selling price to the selling broker.

MTG: Free and Clear TAXES: Approx. $139.23

LISTING NO. 80340 574

PREVIEWS INCORPORATED ● *The National Real Estate Clearing House*
49 East 53rd St. 266 S. County Rd.
New York 22, N. Y. OR Palm Beach, Florida
PLaza 9-2650 Palm Beach, TEmple 2-7131
New York, Boston, Philadelphia, Palm Beach, Chicago, San Francisco, Los Angeles, Denver

The "Industrial Tract" offered for sale as described in the flyer above included much of the land now occupied by the Richmond Heights subdivision lying between the former Seaboard and Atlantic Coast Line Railroad tracks on the north side of Bryan Neck Road (State 63 in the 1940s and 1950s, later State 144). This 210-acre parcel was offered at $95,000.

BIBLIOGRAPHY

Bryan, Ford R. *Beyond the Model T: The Other Ventures of Henry Ford.* Detroit: Wayne State UP, 1990.

———. "Guide to the Records of Richmond Hill Plantation, 1925–1952." Dearborn, MI: Ford Archives, 1983.

Butler, Scott, Joseph Charles, Connie Huddleston, Heather Mauldin, Whitney Olvey, Jen Webber. *The Ford Plantation Project: Archaeological Data Recovery at Dublin/Richmond Plantation, Bryan County, Georgia.* Atlanta: Brockington and Associates, Inc., 2003.

Hoffmann, Charles, Tess Hoffmann. *North by South: The Two Lives of Richard James Arnold.* Athens: University of Georgia Press, 1988.

Livingston, Gary. *"Among the Best Men the South Could Boast": The Fall of Fort McAllister.* Cooperstown, NY: Caisson Press, 1997.

Long, Franklin Leslie, and Lucy Bunce Long. *The Henry Ford Era at Richmond Hill, Georgia.* Richmond Hill, GA: self-published, 1998.

Miller, J. J., Mildred L. Fryman, J. W. Griffin, C. D. Lee, and D. E. Swindell. *A Historical, Archaeological and Architectural Survey of Fort Stewart Military Reservation, Georgia.* Athens, GA: Professional Archaeological Services, 1983.

Rutland, Jerry. *Echoes of the River Bend.* Richmond Hill, GA: self-published, 2003.

Savannah Morning News. Savannah, GA: 1925, 1931, 1947, 1951, 1952.

Sullivan, Buddy. *All Under Bank: Roswell King, Jr. and Plantation Management in Tidewater Georgia, 1819–1854.* Hinesville, GA: Liberty County Historical Society, 2003.

———. *From Beautiful Zion to Red Bird Creek: A History of Bryan County, Georgia.* Pembroke, GA: Bryan County Board of Commissioners, 2000.

Swiggart, Carolyn Clay. *Shades of Gray: The Clay and McAllister Families of Bryan County, Georgia During the Plantation Years.* Darien, CT: Two Bytes Publishing, 1999.

INDEX

DISCOVER THOUSANDS OF LOCAL HISTORY BOOKS FEATURING MILLIONS OF VINTAGE IMAGES

Arcadia Publishing, the leading local history publisher in the United States, is committed to making history accessible and meaningful through publishing books that celebrate and preserve the heritage of America's people and places.

Find more books like this at
www.arcadiapublishing.com

Search for your hometown history, your old stomping grounds, and even your favorite sports team.